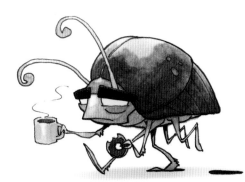

the daily zoo vol. 3 healing together

Chris Ayers

designstudio|PRESS

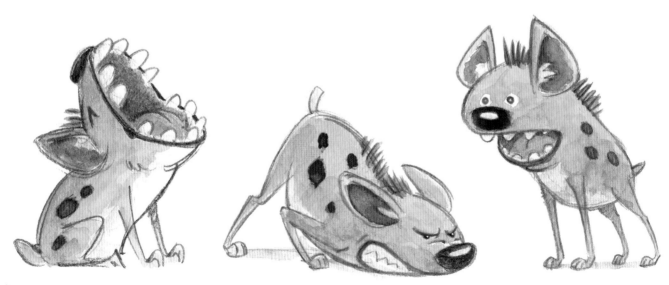

To Zaden

What an amazing adventure you have given
your mom and me in these first two years.
We can't wait to see what's next.

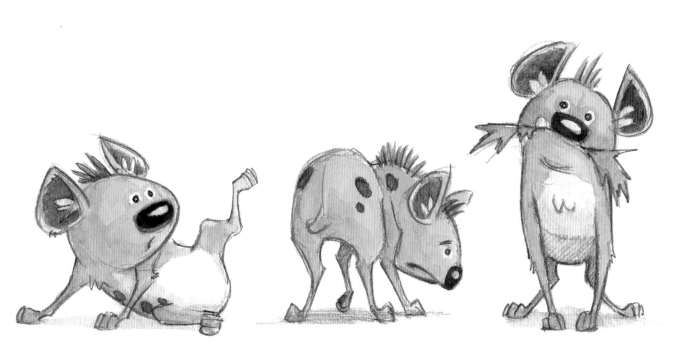

In Memoriam

"Uncle" Bill Bohné, beloved longtime art professor at St. Norbert College, who valiantly fought a lengthy battle with cancer. He knew his art, he knew his wine, and he knew how to live his life to the fullest.

ACKNOWLEDGMENTS

Thank you, Thasja-mia and Little Z, for your love, patience, and making each day a little more special. I would also like to thank my family and friends, as always, for their continued support and encouragement. (Plus, a special shout-out to Little Miss Ivy—welcome to the family!)

My deepest gratitude goes to Dr. Gary Schiller and the UCLA team for being a major reason why I've been able to continue this journey. Similar gratitude is extended to Dr. Jackson Wu, nurse Ruthie, and the rest of the UCLA in vitro team for helping Little Z come to be!

Sincere appreciation is bestowed upon the hardworkin' crew at Design Studio Press, especially Scott Robertson and Tinti Dey for their guidance and support.

Thank you, Tim Vechik, for sharing your photographic know-how and creative eye. Thanks to Brett and Julie Bean—your thoughtful feedback over veggie lasagna helped me figure out how to make this book even better.

Grazie mille to Manuel Turri, Sara Roversi, and ANT for making Bologna happen. And while we're on the subject of Italy, many thanks to Emanuele, Antonio, Pierpaolo, and the entire Lucca Comics & Games crew for their hospitality and invitation to be a Featured Guest Artist in 2012.

Thank you to zookeeper Jo Magana and her L.A. Zoo coworkers for generously sharing your time and your furred, feathered, and finned friends with my family and me. The same goes for zookeeper Liz Cunningham-Beem and company at the Santa Barbara Zoo as well as Fred and Joy Frye and the staff of the San Diego Zoo. Your intimate animal encounters have been a cherished source of inspiration and wonder.

Finally, thanks to the many fine organizations out there working hard to find a cure for cancer and providing comfort, information, and aid to families touched by this disease. I appreciate the opportunities you have provided for me to share my story and art.

Contact info:
To contact the artist please visit **www.ChrisAyersDesign.com**

Non-labeled image titles:
pg. 1: Day 1261 (YR4) - *Morning Joe*
pg. 2: Day 2685 (YR8) - *Alessandro Says, "Ciao."*
pgs. 4–5: Day 915 (YR3) - *H-Y-E-N-A Spells T-R-O-U-B-L-E*
pg. 7: Day 1620 (YR5) - *Eyestalks*
back cover: Day 3259 (YR9) - *All for One and One for All (or Three Times the Hurt)*

Copy editors: Thasja Hoffmann, Nan Ayers, Colleen Ayers, and Teena Apeles
Book design and production layout: Chris Ayers
Photography credits: Tim Vechik (p. 8), Thasja Hoffmann (p. 16), Nan Ayers (p. 41 top left), Jim Ayers (p. 41 top right & bottom right)

Published by Design Studio Press
8577 Higuera Street
Culver City, CA 90232
http://www.designstudiopress.com
E-mail: info@designstudiopress.com
10 9 8 7 6 5 4 3 2 1

Printed in China, first edition, June 2015

Hardcover ISBN 13: 978-162465022-2
Paperback ISBN 13: 978-193349293-3

Library of Congress Control Number: 2015932026

contents

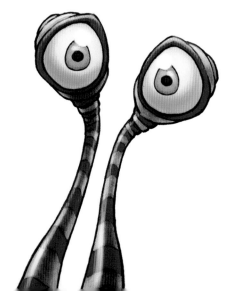

introduction

As I sit down to write this introduction it is Day 3054 of the Daily Zoo, or a little over a third of the way through Year Nine of the project. When I started drawing an animal a day in 2006 on the one-year anniversary of my April 1st leukemia diagnosis (that's right, I was told that I had cancer on April Fool's Day!), I certainly had no idea that I would still be adding to this collection over three thousand days later. In fact, at that time, I wasn't sure whether I would still be alive nine years later.

Shortly out of treatment and having only recently begun to feel back to "normal" physically, I was not spending my days looking years ahead. Instead, I was more focused on appreciating the day at hand and slowly re-acclimating to some of the activities I had enjoyed pre-cancer. Perhaps more important, much of my conscious thought—and probably a lot of my subconscious thought as well—was devoted to trying to process and more fully understand what had just happened to me. The journey of the previous year had been a doozy: full of grave uncertainties, pendulum-like swings across the emotional spectrum, and an inordinate number of needles. I was confused. I was also curious. Curious to discover how that journey had affected me and curious to start getting to know this new me: Chris Ayers, *cancer survivor.*

With time, and certainly with the help of many others, I have come to a point where, nine years later, I'm *living* my life. I've been able to regain control over the volume knob of my apprehension and fear. It will never be completely muted, but now, for the most part, I can keep it to a murmur.

So much has happened since I was treated for leukemia and given a new lease on life. I've gotten married and, through the miracle of in vitro fertilization, become a father. And in terms of the Daily Zoo, it has been a most unexpected journey. Along the way I've been introduced to beautiful and inspiring people including fellow cancer survivors, artists, and fans from around the world. It has led to such extraordinary

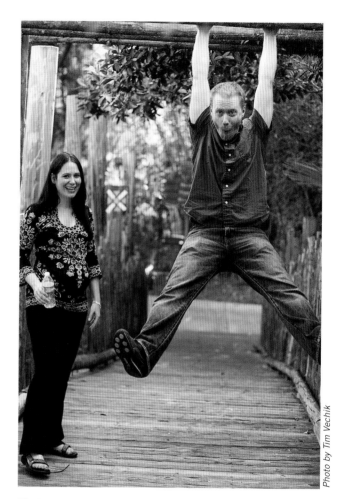

Photo by Tim Vechik

Much has happened since the publication of The Daily Zoo, Year 2, *not the least of which is that Thasja and I became parents. On a visit to the San Diego Zoo Safari Park, I channeled my inner ape as excitement was in the air while we awaited the arrival of our son.*

opportunities like exhibitions of my work in Paris and Italy and speaking engagements both here in the U.S.A. and abroad. It has also introduced me to cancer-related organizations such as the Mayo Clinic, the Leukemia & Lymphoma Society and Be the Match (operated by the National Marrow Donor Program), and I have been fortunate to collaborate with them in raising funds and awareness to fight this disease.

But one of the most rewarding results of sharing my experience of using art as a healing tool has been that it has helped others in their own healing and artistic journeys. The Daily Zoo project was conceived as a healing tool solely for myself. It began as a very intimate daily exercise between my imagination and a pencil and paper. I was calling upon my lifelong love of drawing animals to help bring a new dawn to the darkness that cancer had cast. Publication of the drawings was never the original goal but when that opportunity arose, I jumped at the chance.

Through the books, to my sincere amazement, the Zoo has now become a healing tool for others as well. I have received countless messages from people of all ages who are facing a variety of struggles.

Many cancer patients have found the humor and heart of the books to be a welcome distraction from the rigors of treatment, as well as a source of hope for recovery. Artists from across the spectrum of skill levels have responded to the images and message of pursuing creative passions on a daily basis. Many "former" artists have told me they've been inspired to dust off their old sketchbooks and start drawing again. All of this has been gratifying, of course, but I also find that having my work resonate so deeply with others is humbling, and can be overwhelming at times.

The Daily Zoo may have inspired some of you, but you in turn have inspired me with your comments and your own stories of facing challenges. These experiences are healing for me in that they reinforce my decision to do the Zoo and to share my journey and art with others. The more positive influence my work may have, the more the scars of my own cancer journey seem to fade.

If you're familiar with the first two volumes of *The Daily Zoo*, and if you have already flipped through the pages of this third volume, you may notice some differences.

THINKING OUTSIDE THE BOX
DAY 1001 YR3 12.26.08

When designing this book, I initially struggled to find inspiration similar to what I experienced on previous books. I "thought outside the box" for a bit, which led me to reimagine how I would like to present this volume of The Daily Zoo.

Most notably, whereas the first two volumes each contained all of the drawings from their respective year of the Zoo, this book does not include all 365 drawings from Year Three. Instead, it contains a selection of images from Years Three through Nine.

Let me explain. Initially, my plan for this book was to continue the format that I had previously established and dedicate it solely to the daily drawings from Year Three. But as I began the process of assembling the images into book format, I found myself struggling to find the same excitement and inspiration that had been present when working on the first two books.

For the first book I had worked hard to create a format that allowed room to tell my story but also present the artwork well. This latter part was challenging. How do you fit 365 images into a 160-page book? I ended up featuring selected images in the main body of the book and then the entire year's worth as a calendar in the back; a sort of visual index. This format worked well for those first two volumes, but as I continued to work on *Volume Three*, it didn't seem as necessary.

One of the obstacles to sticking with the established format was that the art of Year Three was now six years old. I believed that much of it was still of good quality but also I felt that my skills had improved since then and so was eager to share more recent work. More pressing, however, was the perceived weight of falling further and further behind in publishing the various Years of the project. I foresaw this getting worse, as I have other non-Daily Zoo projects that I would like to produce as well as additional responsibilities now that I'm a father. These are all good "problems" to have, of course, but it didn't change the fact that, in terms of getting fresh Daily Zoo material to market, I would always be playing catch-up. I would always, in a sense, be chasing my own tail. (This realization inspired Day 2720's tiger doing just that.) And the Daily Zoo is not intended to be about "weight." If anything, it is about lightness: the lightness of spirit that comes from making time to pursue creative adventures and doing what you love to do.

My wife Thasja—whom I've come to trust as an invaluable creative sounding board and co-conspirator—witnessed my struggles and encouraged me to *shake it up!* "The Daily Zoo is your deal. Who says you have to follow the same 'rules' of the previous books?"

But I was stubborn...at least for a while. My mindset was that I would eventually put out an edition of *The Daily Zoo* for each year, containing all the images from that particular year. Neat. Organized. Complete. But if life thus far—not to mention cancer—has taught me anything, it's that things are quite often *NOT* neat, organized, and complete. They are more often messy, chaotic, and fragmented.

It took time, but finally, during an encouraging dinner conversation with Thasja and a few art colleagues, I settled on the idea of a reimagined format for this book. And the more I thought about what that might be, the more excited I got. Ultimately I decided to use this third volume to highlight selected images from the past six years of Daily Zoo drawings. And not feeling bound to show them in chronological order freed me to present them thematically, grouped into chapters that reflect my ongoing journey as an artist, cancer survivor, husband, and now father.

And for you hard-core fans out there, fret not. There are a lot of interesting Daily Zoo characters from recent years that, while not being able to squeeze their way into this book, will hopefully appear in future volumes...however those may end up looking.

I hope you enjoy!

CHRIS

August 8, 2014
Day 3054 of the Daily Zoo

PERPETUAL PLAY

VICK-torious!
DAY 2674 YR8 7.24.13

This was drawn in honor of Vicky, a cancer patient whom I knew only through emails. I tried to capture the impressive dignity and defiance she brought to her fight, a fight that, sadly, she would ultimately lose. But in my mind, she was victorious in the way she fought and handled her situation.

healing
together

The healing process from my battle with cancer has been a lengthy one. I was fortunate that the physical healing took only about a year. The emotional, mental, and spiritual aspects, however, have taken much longer. In fact, they're probably still taking place to some degree, at least in the sense of trying to understand how my "dance with the cance" fully affected me.

In some regards I had to confront cancer by myself. A lot of it was an internal mental ordeal and, as much as loved ones tried to help, it was not their bloodstream being ravaged by leukemia cells, nor were they participating in a wrestling match with their own mortality. The chemo wasn't making them nauseous or causing their hair to fall out (though two good friends did shave their heads in solidarity).

But at the same time I was not alone—far from it, in fact. I've probably never felt less alone than when I was fighting cancer. My girlfriend (who is now my wife), family, friends, coworkers, employers, and former teachers and classmates—not to mention the vigilant UCLA medical team—all surrounded me with support and encouragement. I discovered a great deal of strength from deep within—some of which I didn't yet know I possessed—but I also pulled an equal if not greater amount of strength from those around me. I can't imagine how much harder the journey could have been without this support system. The majority of the time, I felt we were all in this together.

Healing together is cathartic. I've witnessed this at events when survivors and caregivers tell their stories. There is healing power in giving voice to the pain, especially amongst those who can relate. People sometimes ask if I'm comfortable talking about my cancer experience. I imagine they are wondering if perhaps it is too painful or private, but I enjoy telling my story. It's a continuation of my healing and also a reminder of where I've been and what I've been through, which gives me additional strength and fuel for where I'd like to go.

THE ONCE (AND FUTURE) PHOENIX
DAY 743 YR3 4.12.08

I asked my wife to suggest a subject for my sketch of the day. When she said, "Phoenix," I doubt this is what she had in mind. I like to challenge myself to come up with unique and unexpected interpretations of her requests, something that will surprise her as well as me. For those unfamiliar with the phoenix, it is a mythical bird that has the ability to burn to ash, only to be reborn again from its ashes.

ROCKY REBIRTH
DAY 744 YR3 4.13.08

After entering remission from my leukemia, I felt I had been given a second chance at life, like a phoenix rising from its ashes. I certainly didn't feel as though I had blown my first chance—far from it, actually—but I had been given the opportunity to continue my life while seeing things from a bold new perspective. Cancer brought both complexity and clarity to my life. It trimmed away the fat from my previous definition of priorities. It reinforced and refreshed the value of family, friends, and certainly health. It also allowed me to refocus my creative energies in both my professional and personal artwork. In my case—as is probably true for most, if not all, cancer patients—the process of acquiring this second chance was somewhat rocky. Scary. Tough. Tumultuous. There were times in the hospital when it was touch and go. The experience ranged from uncomfortable to downright painful—mentally, physically, emotionally, spiritually. Now that I have taken flight once again, this second chance—this *rebirth*—tastes oh so sweet!

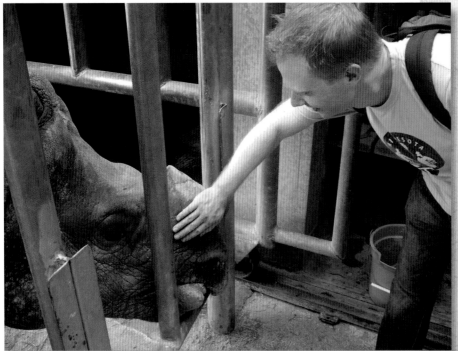

RANDA AT REST ▶▶
DAY 948 YR3 11.3.08

One of the first things I did after moving to Los Angeles in 2000 was visit the zoo, where I snapped a photo of a beautiful Indian rhino having a peaceful moment on a hot day. I eventually used that picture as reference for this sketch on Day 948. Originally titled *Rhino at Rest*, I changed it to *Randa at Rest* several years later when I actually had the chance to be introduced to the two-ton model and to learn that we had more in common than either of us knew.

Randa, you see, is a cancer survivor as well. She was treated for skin cancer in 2007, which necessitated the removal of her majestic horn. She received chemo and radiation treatments from UCLA physicians as did I, though in her case the doctors came to her. I don't think they make hospital beds—or hospital gowns for that matter—big enough to fit her car-sized frame.

Randa and her many animal kingdom compatriots have helped my healing process by providing inspiration and wonder as I have drawn my way through the days of the Daily Zoo. During our meeting I tried to repay the favor with an all-too-brief massage of her flanks and a few choice apples fed to her extremely flexible—not to mention extremely slobbery—prehensile upper lip.

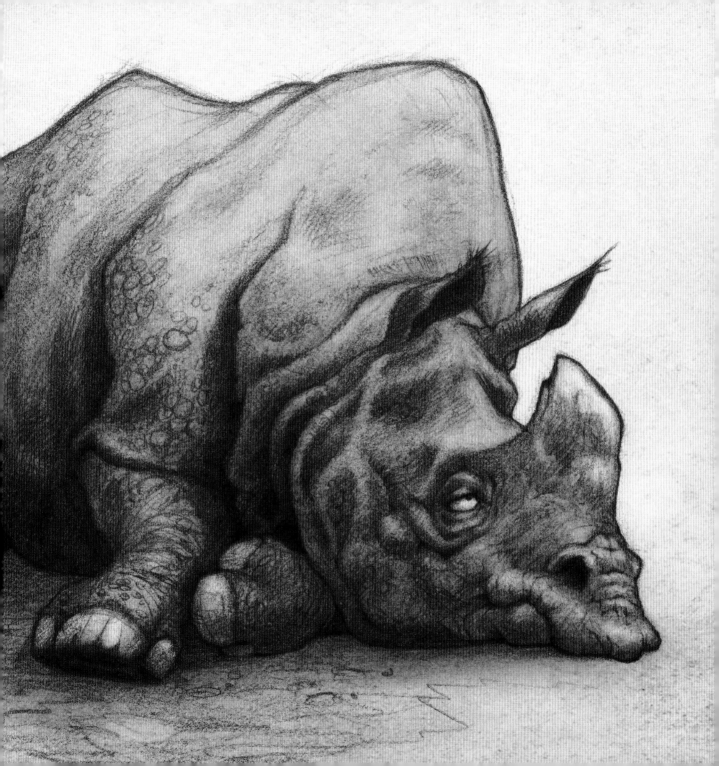

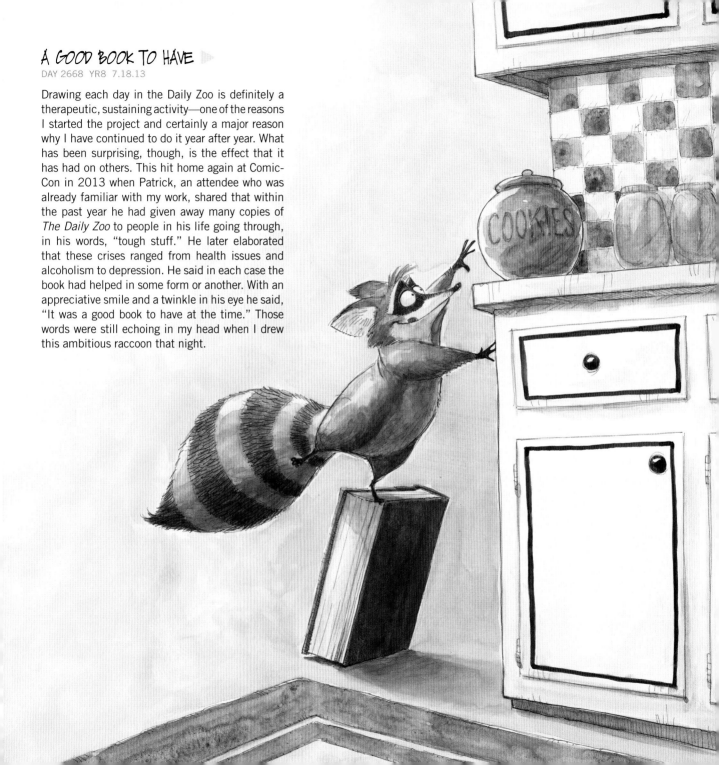

A GOOD BOOK TO HAVE ▸

Drawing each day in the Daily Zoo is definitely a therapeutic, sustaining activity—one of the reasons I started the project and certainly a major reason why I have continued to do it year after year. What has been surprising, though, is the effect that it has had on others. This hit home again at Comic-Con in 2013 when Patrick, an attendee who was already familiar with my work, shared that within the past year he had given away many copies of *The Daily Zoo* to people in his life going through, in his words, "tough stuff." He later elaborated that these crises ranged from health issues and alcoholism to depression. He said in each case the book had helped in some form or another. With an appreciative smile and a twinkle in his eye he said, "It was a good book to have at the time." Those words were still echoing in my head when I drew this ambitious raccoon that night.

Another fortuitous encounter with a fan occurred through an email I received in 2012. Tim, a young photographer, wrote to thank me for *The Daily Zoo*. A few years prior, his parents had had me sign a copy for him at a Be the Match Foundation fundraiser. Tim said it had arrived at a time when he was facing his own difficult health situation and that it had provided welcome inspiration, distraction, and support. He also felt that the only way he could fully express his gratitude was to offer his services to do a photo shoot of me at some point.

My expectant wife and I took him up on this gracious offer and met him at the San Diego Zoo Safari Park. While shooting we visited the Petting Kraal, where I had a hands-on encounter with several goats, one of whom just happened to be hiccuping. I dare you to place your hand on the belly of a hiccuping goat and not burst into a smile. I am grateful to the Daily Zoo for introducing me in a roundabout way to that hiccuping goat, but more important, I am grateful that it introduced me to Tim, a kind and inspiring artist in his own right.

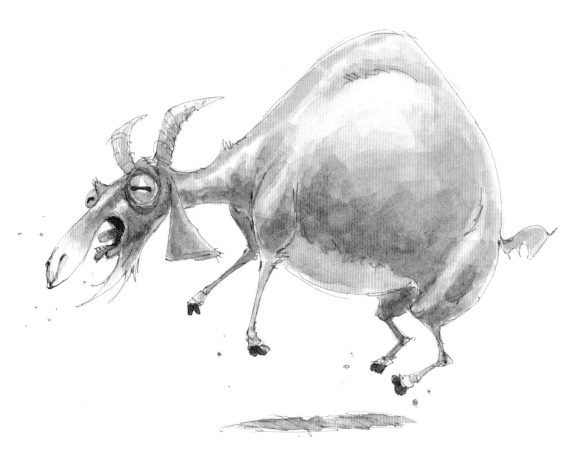

SIMPLY DASHING

DAY 1480 YR5 4.19.10

One of the techniques for idea generation and character design that I demonstrate when I teach or give workshops is something I call the Brainstorm Bag—a simple but very effective tool. Small scraps of paper, on which I've written names of animals, colors, adjectives, objects, occupations, etc., are tossed into a bag. Shake the bag and blindly pick out a few of the scraps. This can create a spark in your imagination and provide a starting point for developing an interesting character and story.

The rather confident-looking warthog in a tuxedo was a result of going fishing in the Brainstorm Bag. When I pulled this colorful combination (warthog, tuxedo) from the bag, I was in the traumatic brain injury (TBI) unit of Bethesda Hospital in St. Paul, Minnesota, in town on a "mini book tour" giving presentations, art work-shops, and book signings at several hos-pitals and clinics. Since it was my first time working with these types of patients, I was unsure how things would unfold. The workshop went well and provided me further evidence of the positive role that creativity and art can play in the process of recovery. The enthusiastic nursing staff was great and provided each patient with as much or as little assistance as required for them to follow along as we all drew something simply dashing.

GARY, THE RACCOON WHO LIKED TO GO FAST

DAY 2095 YR6 12.23.11

The summer before creating this drawing my cousin Brent had helped raise an orphaned raccoon named Gary and they became quite attached to one another. One of their favorite activities was to go cruising around the neighborhood on Rollerblades with Gary perched atop Brent's shoulder.

The concept of healing together doesn't always have to refer to helping one another recover from disease or physical injury. It can be much broader in scope, such as the bond formed between a young man and a young mammal, both with the same yen for speed. Gary obviously benefitted from the shelter, kibbles, and care that Brent provided, and Brent probably benefitted from the companionship and responsibilities of taking care of somebody. I think their time together, though short, allowed each of them to grow in self-confidence.

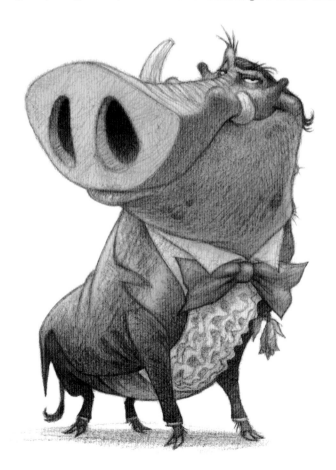

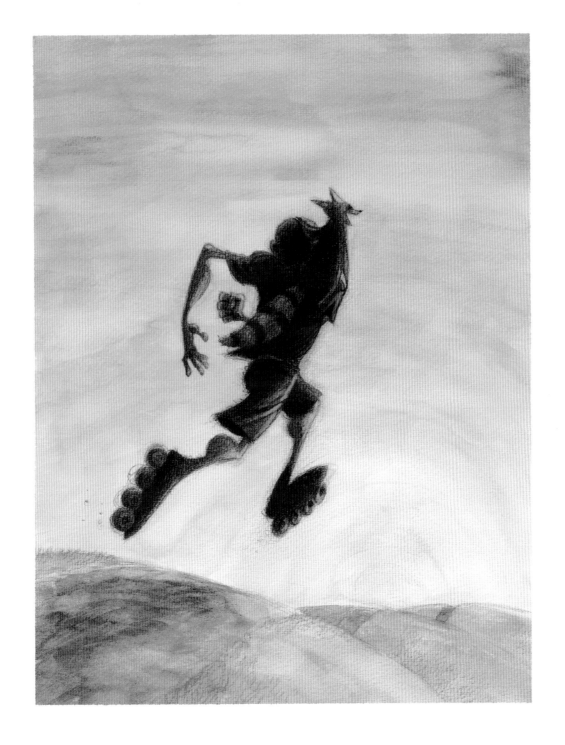

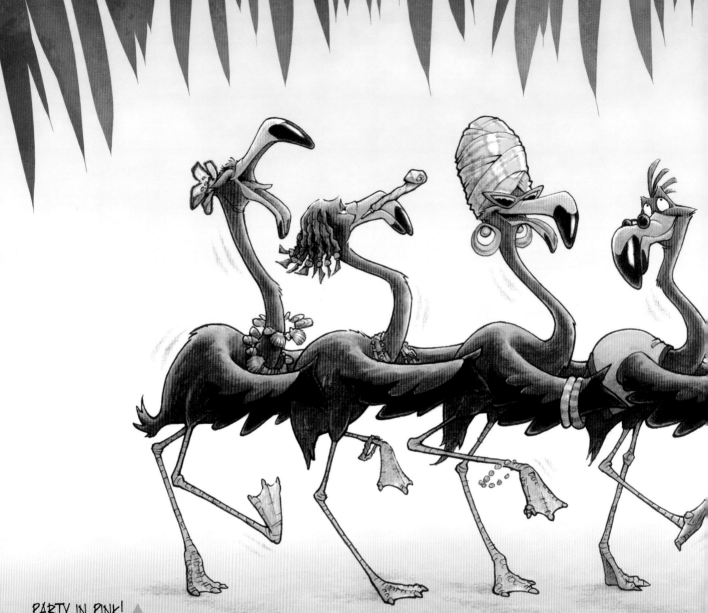

PARTY IN PINK! ▲
DAY 1024 YR3 1.18.09

Shortly after the first *Daily Zoo* book came out, I had the opportunity to collaborate with the Northeast Wisconsin branch of the American Cancer Society. I volunteered to create artwork for invitations to their annual fundraising gala, artwork that would then be auctioned off as part of the evening's festivities. The gala's theme was "Havana, Cuba" and a line of dancing flamingos seemed like a perfect way to go.

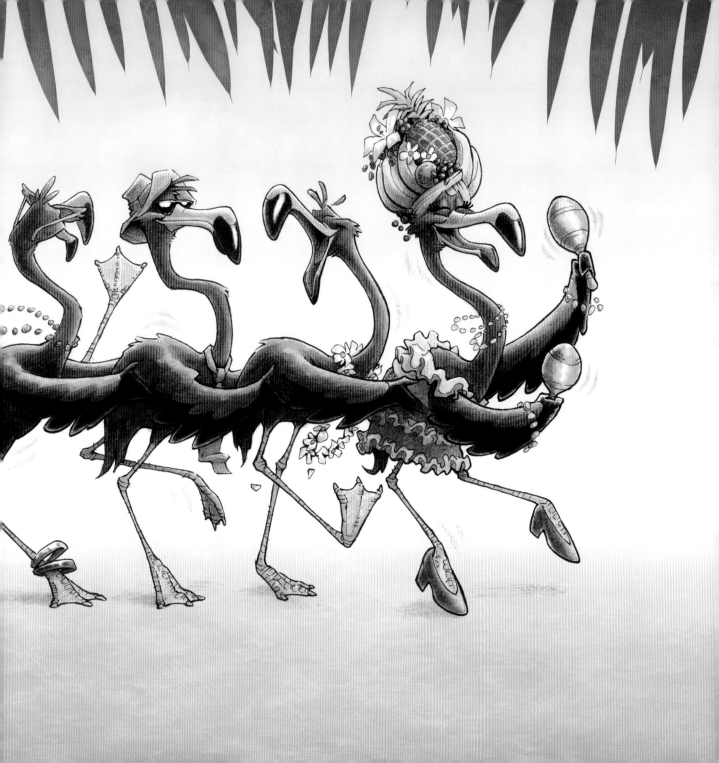

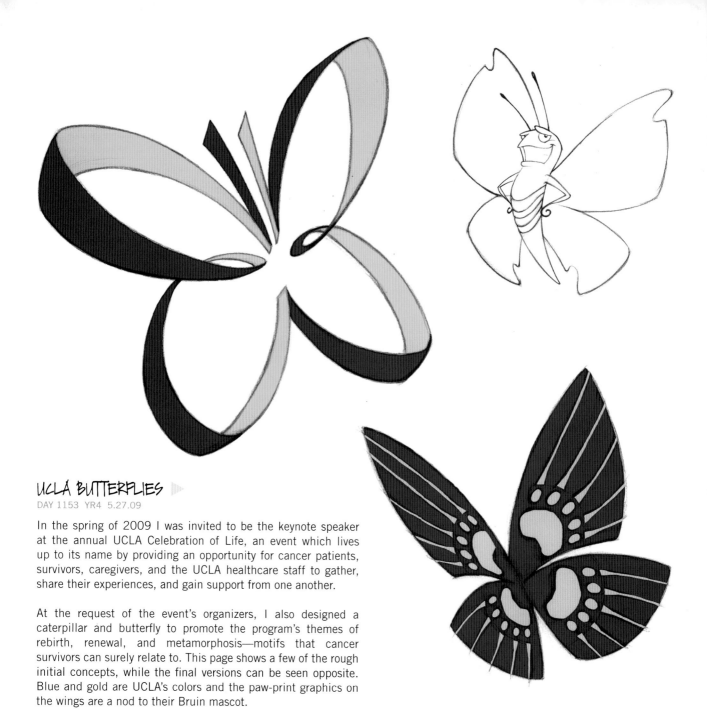

UCLA BUTTERFLIES

DAY 1153 YR4 5.27.09

In the spring of 2009 I was invited to be the keynote speaker at the annual UCLA Celebration of Life, an event which lives up to its name by providing an opportunity for cancer patients, survivors, caregivers, and the UCLA healthcare staff to gather, share their experiences, and gain support from one another.

At the request of the event's organizers, I also designed a caterpillar and butterfly to promote the program's themes of rebirth, renewal, and metamorphosis—motifs that cancer survivors can surely relate to. This page shows a few of the rough initial concepts, while the final versions can be seen opposite. Blue and gold are UCLA's colors and the paw-print graphics on the wings are a nod to their Bruin mascot.

CELEBRATION of LIFE!

TRANSFORMATION · CHANGE · D
HAPPINESS · RENEWAL · JOY · T
METAMORPHO
TRANSITION · H
CHANGE · REBI

TREASURE THIS MOMENT · BE HERE NOW!

REBIRTH · HAPP
RENEWAL · CHAN
TRANSFORMATION

Thursday
July 16th, 2009
11 am - 2 pm
Room 33102
Ronald Rea

Come share your survivor story and hear those of others including guest speaker Chris Ayers, leukemia survivor and author/illustrator of The Daily Zoo: Keeping the Doctor at Bay with A Drawing A Day.

RACING FOR A CURE ▶

One of the organizations with which I have been most involved is the Leukemia & Lymphoma Society. They promote awareness of blood cancers, raise much-needed funds for research, and provide resources and support for those affected by these diseases.

In early 2010, the local LLS chapter in my home state of Minnesota asked me to be the honorary chair of their Man & Woman of the Year campaign, in which individuals compete for those titles through fundraising efforts. These hippos, seen here racing for a cure, were done as a logo to support that year's campaign. I explored several poses with rough thumbnail sketches before proceeding to the final artwork, a process I often use in my freelance work. Daily Zoo characters, however, are usually done in one take.

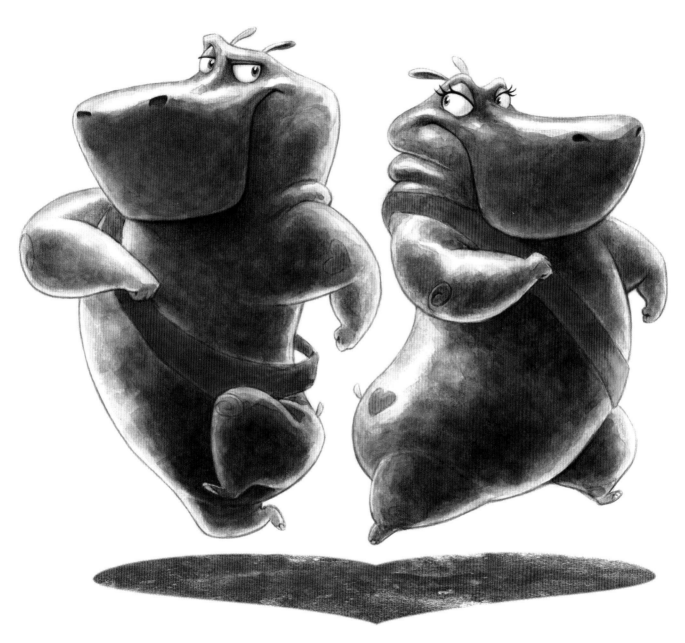

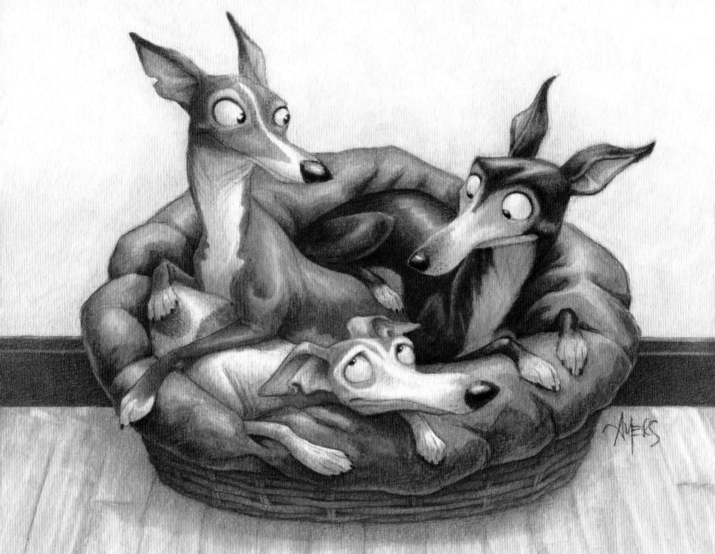

AN INSEPARABLE TRIO ▲

DAY 3204 YR9 1.5.15

Upon learning that I was in the process of putting this book together, my friends at the Minnesota chapter of the Leukemia & Lymphoma Society proposed an interesting item for their upcoming live auction fundraiser: an original Daily Zoo sketch that would be included in this book. The winning bidder would also get to choose the animal. Once the bidding dust settled, Trevor and Craig had helped support the cause with a generous donation and requested that I draw their three Italian greyhounds: Nico, Leo, and Bella.

HERSHEY BEAR

Another unexpected aspect of this Daily Zoo journey has been that I've done more public speaking than I ever thought I would. I'm naturally an introvert and my very shy seven-year-old self would have been mortified had he known that, years down the road, he'd be sharing his story in front of audiences around the world.

I started drawing this bear on the flight home from speaking at a blood cancer conference hosted by the Hershey, Pennsylvania chapter of the Leukemia & Lymphoma Society. He was suggested by one of the attendees during the Q&A session:

"Have you drawn today's animal?"

"No, not yet."

"How about a Hershey bear, that's the mascot of our local hockey team?"

"A Hershey bear? Hmmmm…"

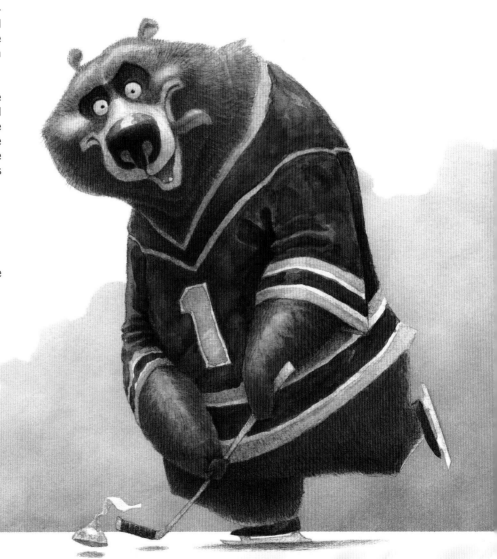

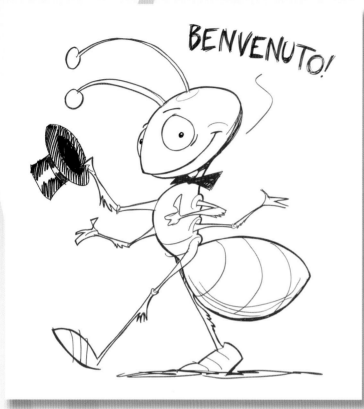

BENVENUTO!

While helping to set up for ANT's anniversary party, I did this impromptu sketch on a large pad of paper to welcome guests as they arrived. Those Italians are no strangers to celebrating and the party was great fun—so much fun, in fact, that I didn't get back to my hotel until 3 AM. With little energy left for further drawing, I decided this guy would have to suffice for the Daily Zoo sketch of the day.

ALESSANDRO THE ANT ▶

DAY 2565 YR8 4.6.13

On this day I spoke at the University of Minnesota's Cancer Survivorship Conference, but the ant I drew for my animal that day was in preparation for the *next* speaking engagement. At the invitation of Fondazione ANT (Associazione Nazionale Tumori), I would soon be heading to Bologna, Italy.

ANT was having a big party to celebrate its 35th anniversary of providing, among other services, in-home, end-of-life care for terminally ill cancer patients. As part of the celebratory activities, an exhibition of Daily Zoo art was on display and I took requests for quick sketches to raise funds for the organization. Alessandro here was created for ANT to use on the party invitations and promotional posters. A few days after the party, and with the help of a translator, I presented the story of my cancer journey and *Lo Zoo Quotidianoto* to the ANT staff.

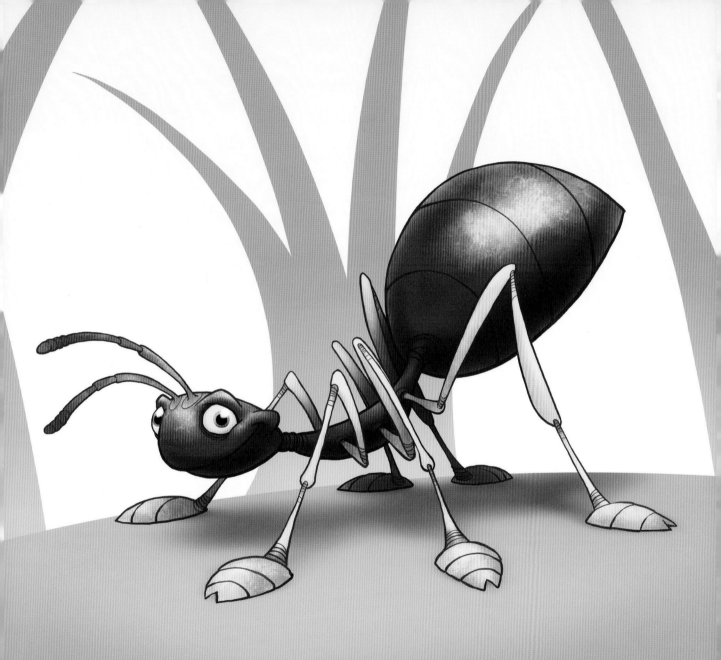

CRUISIN' FOR QUASARS ◄
DAY 1531 YR5 6.9.10

This piece was created to adorn T-shirts for the Minnesota Angel Foundation's annual Kids Kamp, a summer retreat for children who have a family member undergoing cancer treatment.

ERICA'S CHEMO DIDN'T WORK ▼
DAY 944 YR3 10.30.08

I had a heavy heart when I drew this mouse. Moments before, I had learned that Erica's latest round of chemo had not worked as hoped. After two previous relapses of cancer, her options were few and all of them bleak. She and I had never met but only knew one another through an email correspondence that I had initiated after seeing her and her sister sing "If I Had the Perfect Donor" online. Their song was a plea for people to register with the National Marrow Donor Program's Be the Match Registry. Sadly she was the third person I knew who had relapsed in the past several weeks.

HELGA THE HEARTY ▲
DAY 2346 YR7 8.30.12

Helga, the heartiest and feistiest of German stem cells, came about at the request of two longtime friends of my parents, Bill and Margaret. Bill emailed me in the summer of 2012 to tell me about his niece who was battling cancer and had just received a stem cell transplant from a donor in Germany. In an effort to help lift their niece's spirits, Bill and Margaret concocted a story of Helga, a no-nonsense, all-business, sauerkraut-and-kickbuttwurst kind of fräulein. Bill asked if I would do a sketch of Helga. With the vivid description they provided, it wasn't hard to do. So, cancer cells, you've been warned…*ACHTUNG!*

HULAGATOR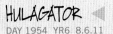

DAY 1954 YR6 8.6.11

Sometimes no matter how hard one fights, no matter how upbeat and positive one remains, the journey ends all too suddenly. As with Erica's mouse on the previous page, a cancer patient inspired this Hulagator, shown enjoying a peaceful moment while riding the gentle current of the cosmic flow. This time I knew the patient well. Cheryl was the mother of close friends and had become a friend herself.

Earlier in the day Thasja and I had attended a luau in Cheryl's honor. Cancer treatments and numerous medications had altered her physical appearance but not her spirit or smile. Time and experience had etched lines into her face but when she smiled they became a dazzling pattern, radiating from the corners of her eyes like rays from the Hawaiian sun that she so enjoyed. At the time we could not have known that she would pass away just four days later, but in hindsight, I can't think of a more perfect send-off for her. She spent a gorgeous, sunny afternoon surrounded by family and friends who loved and cared for her deeply and also got to watch her daughter and granddaughter dance hula.

The title of this chapter is "Healing Together," yet I've mentioned several cancer warriors who ultimately lost their battle with the disease. What impressed me about each and every one of them was the positive attitude with which they chose to face their challenges. They did not let the cancer define them. While it's true that cancer had violently jerked their steering wheels, they did their best to stay on the road, logging miles on their terms until their vessels finally ran out of gas. Despite their physical "defeat," all were victorious in areas they could still control: attitude and spirit.

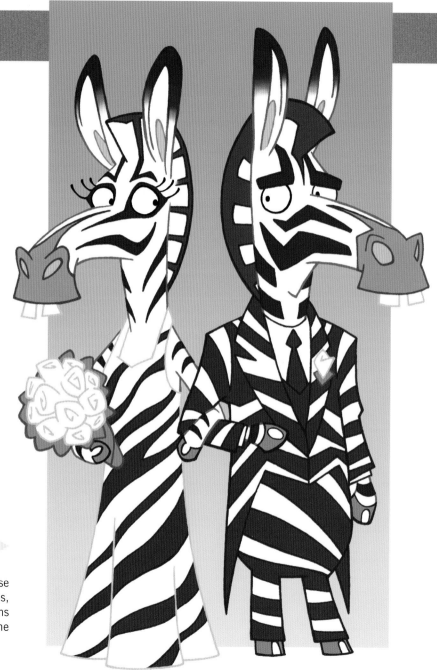

A MOST STRIPED AFFAIR

"You're Invited!" Those words, and these zebras, adorned the invitations to our wedding at the Minnesota Zoo.

goin' to the ~~chapel~~ Zoo

Healing *together.* As I've already mentioned, I have been fortunate to be surrounded by a great many supporters during my ongoing journey of healing, recovery, and now *life.* Since my cancer, however, there is one person who has put in more time by my side—caring for me, supporting me, encouraging me—than any other: my wife, Thasja. From first suggesting (okay, *demanding*) that I see a doctor when I was so fatigued and battling a sore throat that would not heal, to making sacrifices both large and small in the interest of our relationship and the life we are building together, she has been a constant companion and source of support. So once the dust settled from my dance with cancer, it was an easy decision to ask her to marry me.

And when she said, "Yes," (quickly and without hesitation, I might add—*ahem*), we then had to decide *how* we wanted to get married. We briefly considered avoiding the potential stress of planning a wedding by eloping. But ultimately it was very important to us to celebrate this next step of our journey together with many of the people who had held us during those dark days of uncertainty and fear.

After discussing many options, we decided to tie the knot at the Minnesota Zoo, a setting that we felt reflected who we are. Both very inspired by animals, we have spent much time together at zoos over the years. In addition, it was a unique setting and seemed as though it would be a lot of fun for both our guests and ourselves.

So with the cold nip of a Minnesota October evening lingering outside, Thasja and I exchanged vows in the jungle at the head of the Tropics Trail. Shortly before the ceremony started we all were treated to a raucous chorus of hoots and howls from the nearby lemurs. It was as if they were saying, "Let's get this party *started!*"

TABLE MARKERS ▼ ▶

DAY 1185 YR4 6.28.09
and DAY 1186 YR4 6.29.09

Like most couples, Thasja and I at-
tempted to add our own personal touch
to the wedding festivities. One idea was
to use animals to mark guest tables
for the reception dinner rather than
numbers. Each guest's name card had a
Daily Zoo critter on it that corresponded
to a specific table. We thought it might
be more interesting for our guests to
discover that they were seated at the
Jackamoose Table rather than Table 6.

PAPER-FOLDED PACHYDERM ▷

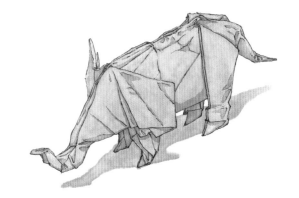

In addition to making our own invitations, thank you notes, table markers, and name cards, we also designed and assembled the centerpieces. We thought it might be striking to have a variety of origami animals hanging from willow branches on each table and inviting our guests to take them home.

Great idea, but who's going to make them?!! My perfectionist tendencies reared their ugly heads as I found probably some of the most elaborate and most difficult origami patterns the Internet could serve up. I managed to make about three, including an elephant that took me nearly two hours to complete (sketching it for Day 1034 took considerably less time). Fortunately Thasja, my dad, sister, and a prolific paper-folder friend of my parents, Satenik, came to the rescue and created a most magnificent origami menagerie.

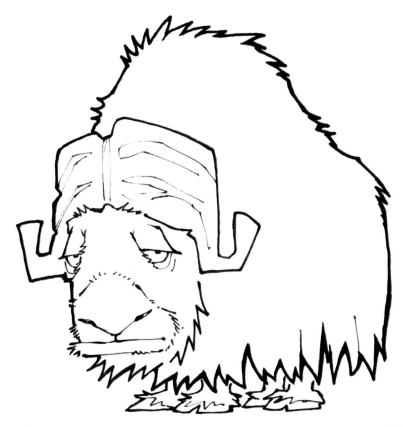

COLLABORATIVE ELE-BEAST ▲
DAY 1132 YR4 5.6.09

Thasja and I "collaborated" on this creature a few months before getting married. We were visiting Minnesota to take care of wedding preparations and ended up one night at Fat Lorenzo's, a favorite pizza joint. The tables at Fat's are covered with white paper and each has a cup of crayons to encourage doodling while you wait for your pie.

Thasja was working on one very pleasant-looking elephant and happened to look away for a moment. I jumped in and, with an audible "*Roar!*," added a couple of red zigzags for ferocious fangs. It was probably the least labor-intensive Daily Zoo sketch I have ever done—and the only reason I let it *count* as the day's sketch was because our upcoming nuptials were on my mind and I liked the idea of a collaboration between the two of us. In reality, marriage is two parties contributing their skills, strengths, and ideas to add to the whole, ideally creating something grander and richer than simply the two individuals. It's *also* about understanding…such as when your partner turns your sweet elephant into a bloodthirsty carnivore.

RED PANDA ▲
DAY 1296 YR4 11.19.09

This curious panda was the first animal to greet Thasja and me as newlyweds. She was perched on a branch as we, now husband and wife, walked through the jungle trail on our way to the reception. I didn't put too much effort into this sketch but, hey, give me a break…it was my wedding night!

WEATHERING THE STORM(S) ▶ ▲

Thasja and I may have been quick to fall in love, but it took a long time for us to get hitched. From our first meeting it took over a year for us to start dating. Six years later, after things had started to calm down following my leukemia interruption, I proposed in Alaska. Finally, two years after that we said, "I do," at the zoo.

We have weathered our share of storms, both literally—as when we got caught in a thunderous downpour riding bikes around Minneapolis lakes—and figuratively (that whole cancer shebang). All of our experiences together, both good and not so good, have forged a framework that we hope will support us through any challenges that may lie ahead.

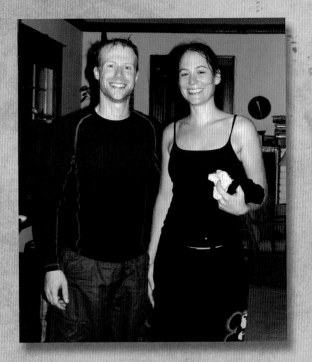

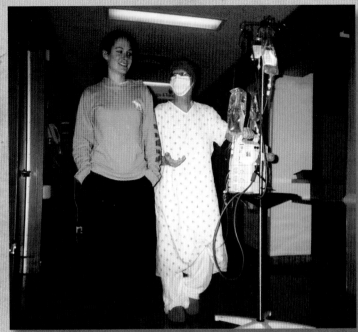

DOLPHIN BLESSING ▶

The whole wedding went smoothly, at least from our perspective. No one was eaten by a tiger or had their cake stolen by a monkey. The dinner, dancing, and toasts all went as planned. But one of the most magical moments of the evening was not on the schedule. The reception was held in Discovery Bay, an area of the zoo containing touch tanks, sharks, and dolphins, with the head table situated right in front of the dolphin tank. At one point during dinner Thasja and I heard excited gasps and shrieks from the room full of guests. We turned around and came nose-to-bottlenose with a dolphin. He was just hovering there, right between Thasja and myself, gently bobbing his head. He did this for a while. Eventually I extended my hand to the glass and nodded back. As if he knew his message had been received, he did one final, deep nod—almost a bow—and then swam off. How many couples can say their union has received a dolphin's blessing?

41

SATURATED
DAY 1297 YR4 10.18.09

All I could think to draw on the day after our wedding was a sponge. It came closest to how I was feeling: completely saturated! Saturated with love from family and friends. Filled with rich memories from the celebration. Overflowing with appreciation for Thasja, my true companion. It was so much goodness that I couldn't soak up any more. As the saying goes, our cup had runneth over. But that's not quite accurate, for we didn't feel like cups—we were not simply holding the love that had been showered upon us. We had absorbed it; it was running *through* us. Saturating us. It was now, and forever, a part of us.

JUST MARRIED!
DAY 1329 YR4 11.19.09

The striped bride and groom on our wedding invites were such a hit that we had to bring them back for an encore and use them on our thank you cards.

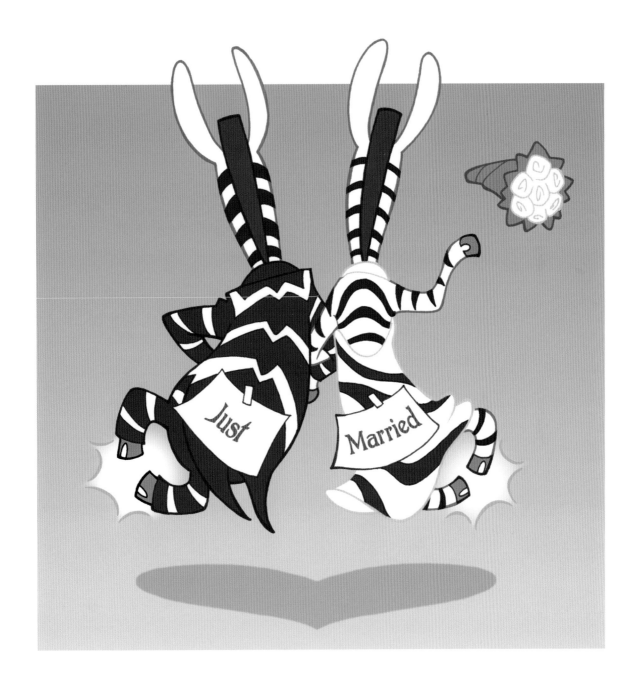

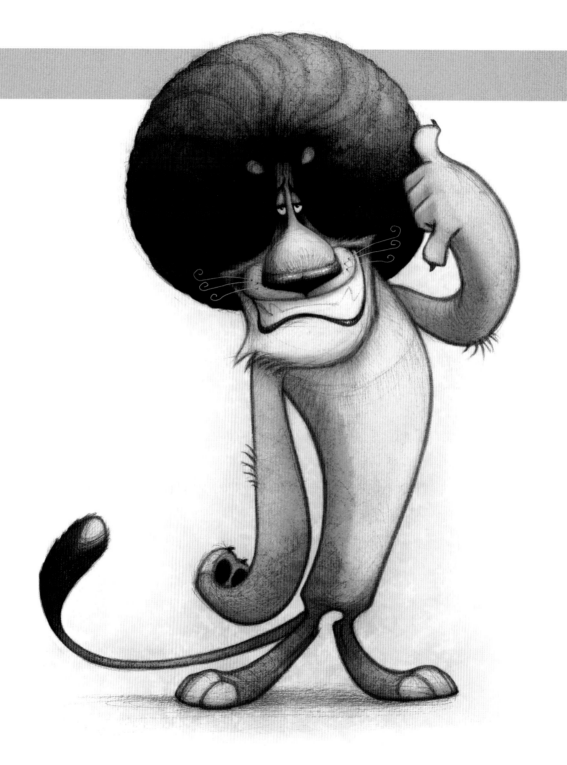

charismatic megafauna

They're big. They're charming. They catch your eye and drop your jaw. In short they are the Major League All-Stars of the animal kingdom. They are the ones known as "charismatic megafauna."

Zoo curators know they need a certain number of big-ticket species like gorillas, elephants, tigers, and giant pandas to draw the crowds necessary to make their institutions economically viable. Charismatic megafauna is the term used to describe these large animal species that elicit broad recognition and appeal to the general public.

And biologists and environmental conservationists know that by bringing attention to the plight of these easily likable "flagship species" they have a better chance of garnering public support and thus government action towards their conservation efforts. People are generally more likely to care about snow leopards than they are about tiger beetles, both of which are listed as endangered species. Working to protect the habitat of charismatic megafauna results in protecting the entire ecosystem it contains.

While I consider myself to be an equal-opportunity animal admirer, finding each species charismatic in its own unique way regardless of size or "beauty," I do admit to a certain degree of heightened excitement and awe when, for example, I find myself in the quiet presence of a silverback gorilla or feel a lion's roar reverberate through my chest. They're not called charismatic megafauna for nothing, after all.

"CALL ME."
DAY 2058 YR6 11.16.11

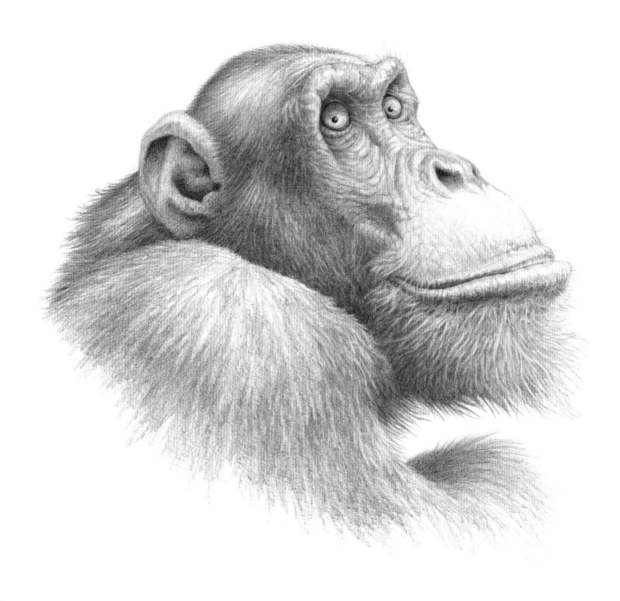

46

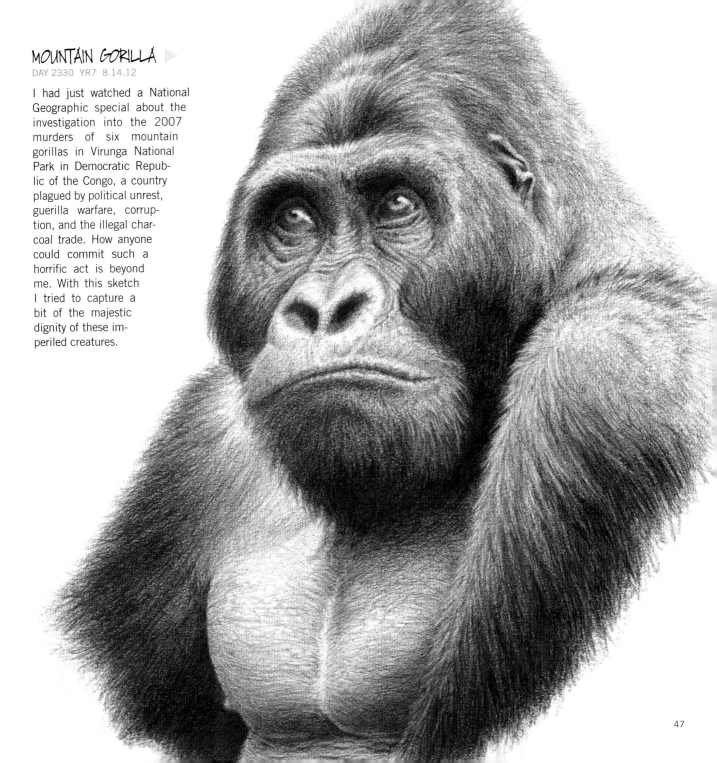

MOUNTAIN GORILLA ▶
DAY 2330 YR7 8.14.12

I had just watched a National Geographic special about the investigation into the 2007 murders of six mountain gorillas in Virunga National Park in Democratic Republic of the Congo, a country plagued by political unrest, guerilla warfare, corruption, and the illegal charcoal trade. How anyone could commit such a horrific act is beyond me. With this sketch I tried to capture a bit of the majestic dignity of these imperiled creatures.

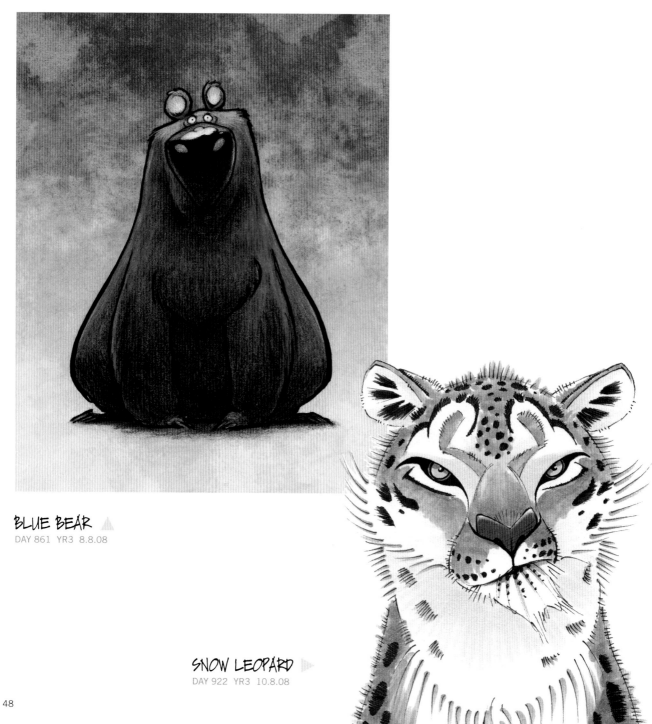

BLUE BEAR
DAY 861 YR3 8.8.08

SNOW LEOPARD
DAY 922 YR3 10.8.08

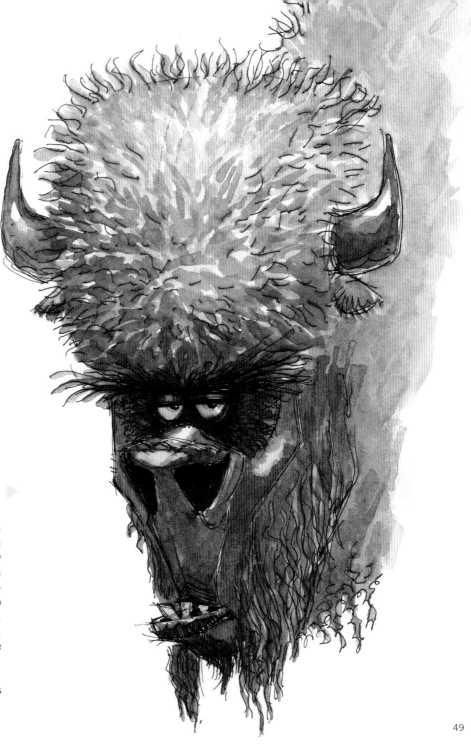

FRANK THE AMERICAN BISON
DAY 2365 YR7 9.18.12

From a biological standpoint, bison are technically not buffalo, though in the U.S. the two names are generally used interchangeably. Early European settlers in America called them buffalo because of their similarities to buffalo in Africa and Asia. However, bison differ in that they are larger, sport thick beards, and massive humps over their shoulders.

Honestly, I don't think Frank cares *what* you might call him.

DARLA DOUXQUETTE, THE PINK DIVA

DAY 2442 YR7 12.4.12

Darla Douxquette, aka The Pink Diva, is one debonair bear extraordinaire. As the heiress to one of the world's largest honey conglomerates, she has ample time and resources to jet-set around the globe in a pink Learjet pursuing her many philanthropic campaigns.

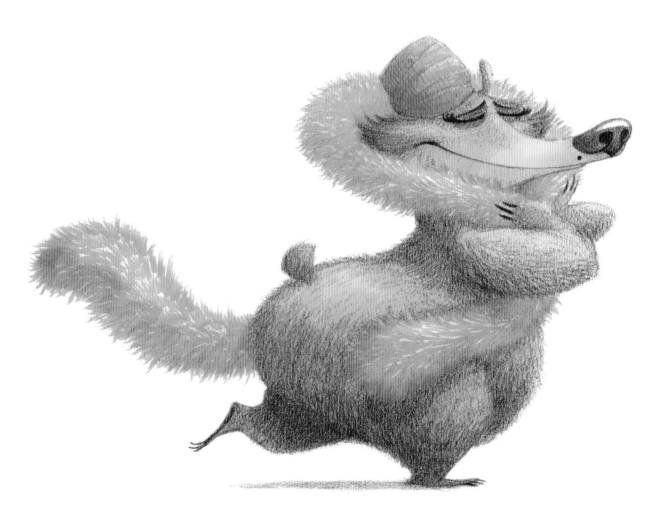

GHARIAL ON THE GO

Gharials, a type of Asian crocodilian, get their name from the Indian word "ghara," which means pot, because of the large, bulbous masses found at the tips of the males' snouts.

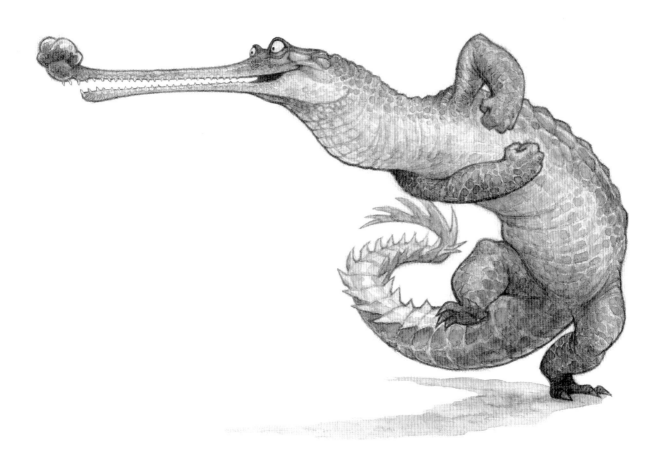

GORILLA

Yes, more gorillas. In addition to being fun to observe, they are also fun to draw. This is partly because they have such interesting shapes and proportions, which provide almost endless possibilities to stretch, push, and explore. Also, they often exude such rich personalities!

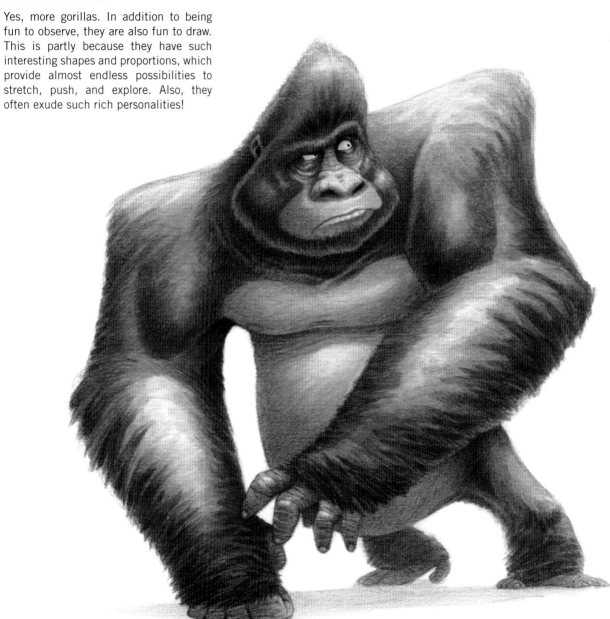

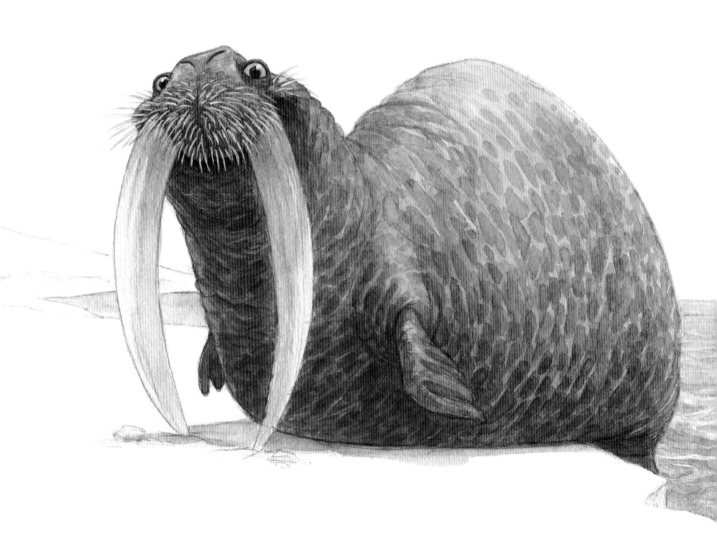

THE TOPIARY KING ▶▶

I have been fortunate to have had an up-close, behind-the-scenes encounter with a pair of lions at a zoo. These big cats are impressive to see from virtually any distance, but to experience them from a few feet away is truly special. I gained an even greater appreciation for their massive size. The sinewy combination of their power and grace was on display as they padded lightly around the enclosure, as well as when they each made an entire rabbit disappear in under five minutes. I was awed and humbled. The title "King of the Jungle" fits them exquisitely.

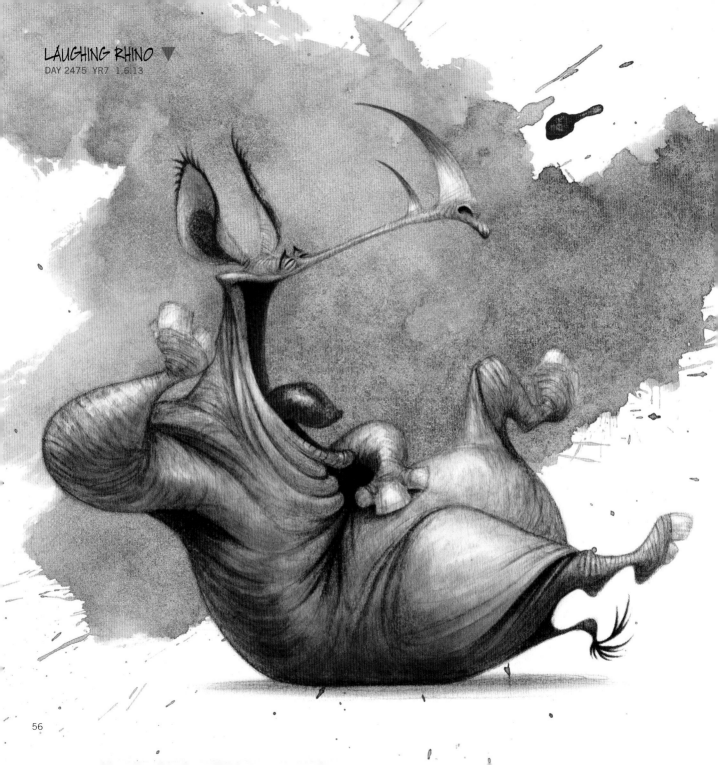

If multicolored sea serpents such as Sherman existed, they would *most definitely* be considered charismatic megafauna.

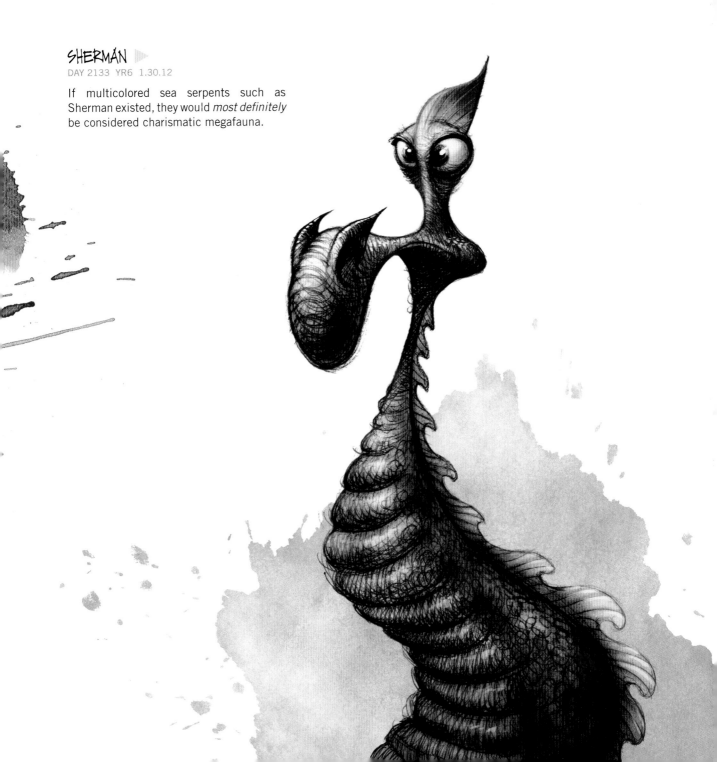

in search of
inspiration

I am often asked where I get my ideas for the characters I draw. Where do I find my inspiration? My blanket response is that I try to keep my senses, mind, and heart open to the world around me. I never know when or from where inspiration might strike or what might trigger a light to go off in my head, be it a firefly or a supernova.

A more specific answer is that a great many sketches are inspired by everyday life. Some, of course, are inspired by big things such as the birth of my son, getting married, or being a cancer survivor. But many come about in much more mundane ways. The trick, I guess, is to try to make magic from the mundane (something that I will be the first to admit does not happen to me nearly as often as I would like). I try to stay curious about the world and retain that sense of wonder that is so strong in us as children.

I also believe that finding inspiration is not a passive activity. If you are waiting for inspiration to strike, I hope you've got a magazine and a comfortable chair, because it could be a long wait. Not to say that it *can't* happen that way, but your chances of encountering inspiration increase if you go *searching* for it. For me this includes things like walking in the woods, reading a book, people watching at a sidewalk café, spending time with my family, and, yes, going to the zoo. And it means *practice*. My day job as a freelance character designer requires me to come up with ideas—ideas that will hopefully appeal to and inspire diverse audiences. Wrestling a blank page day after day for the Daily Zoo, over three thousand times and counting, has been a great workout for my brainstorming muscles.

Case in point: the gorilla seen opposite was done as a demo at an animation expo. Prior to "performing," I had my wife draw three words from my Brainstorm Bag. She drew, in this order, "gorilla," "confused," and "firefighter." Before she had even put the last word down on the table, I had the idea of a

"THAT'S ODD..."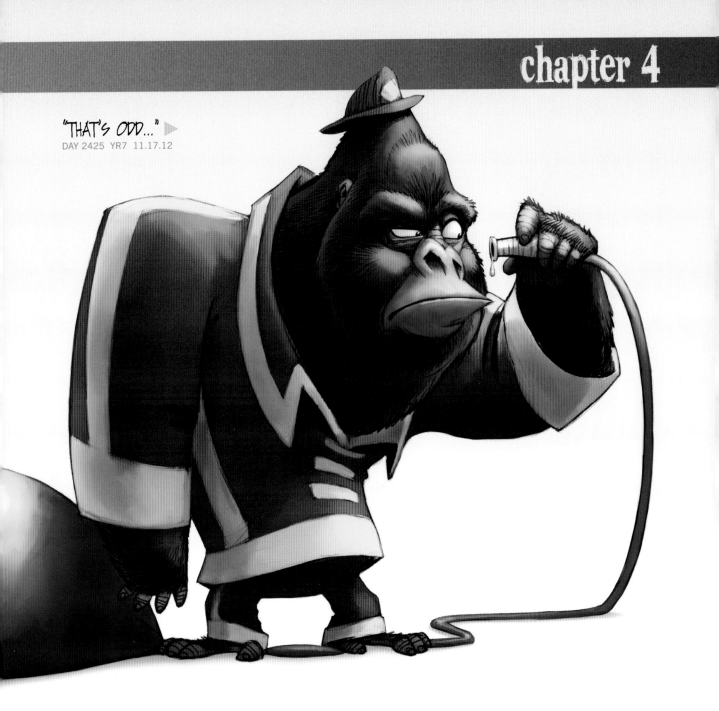
DAY 2425 YR7 11.17.12

simian firefighter befuddled by the lack of water coming from his hose. I was surprised that my mind produced something so quickly, and it made me think this daily brainstorming stuff is starting to pay off!

I should also mention that often I do not have a clear vision in my head when I start to draw. I can't quite *see* it—it's more a vague, foggy notion, or sometimes just a feeling. These drawings can be tougher to finish, but they can also be more fun as they provide a chance to really explore and play with my imagination.

For this chapter I've selected images that were inspired through a variety of methods. Hopefully it will present a better understanding of how my mental gears turn. Through sharing my art and stories in *The Daily Zoo* books, it is my hope that readers, regardless of age or artistic background, will be further inspired to tap into their own imaginations, whether this means creating their own characters and stories or simply looking at the world around them with a bit more wonder.

TIME TO GET BACK TO IT

DAY 1462 YR5 4.1.10

Sometimes I find inspiration for my daily sketch from the significance of that particular day. I drew this pig, rolling up his sleeves and marching determinedly to tackle the task at hand, to start Year Five.

I tend to give extra thought to the sketches done on the first and last days of each year of the Daily Zoo. The days in between can be filled with random rabbits and nonsensical numbats, but I try to bookend them with something that reflects the bigger picture of the journey I'm on. This happens with varying levels of success, of course, but I can identify with the idea behind this pig. I had just finished Year Four on the previous day and now it was time to get back to it and begin Year Five. The thought of another 365 fresh opportunities to play with a blank piece of paper was rejuvenating and exciting. I was curious to see where my imagination would take me next!

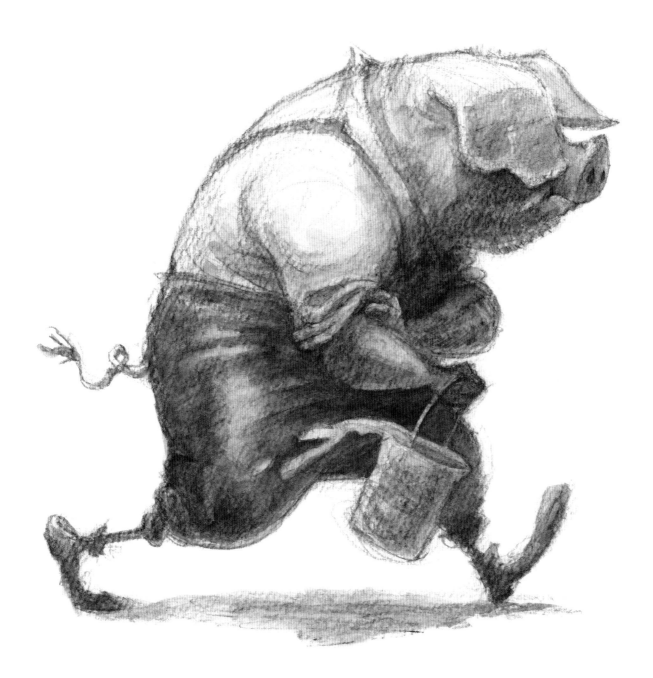

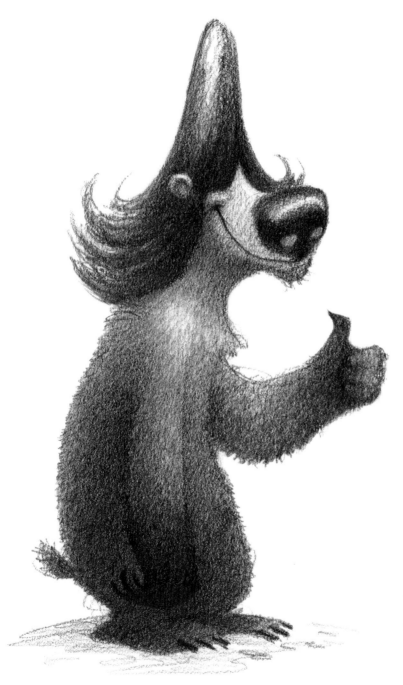

COLIN THE WONDER BEAR
DAY 2075 YR6 12.3.11

Here are three examples of Daily Zoo characters that were inspired by actual people that I have encountered. Without flesh and bone sources of inspiration, these sketches most likely would never have been created.

Colin the Wonder Bear is based on a friend of our next-door neighbors whom we had met a few times at various get-togethers. To know Colin—to spend time with Colin—is to laugh heartily. He is a gentle yet side-splittingly funny character. With a fantastic hairdo to boot!

OFFICER CRANKOWITZ
DAY 2730 YR8 9.18.13

While waiting for my ride to arrive at the Philadelphia airport, I enjoyed watching a traffic cop in action. She was short, slightly hunched over, and had a *great* hairstyle. The way she was directing traffic by swinging her arms around and making shrieking noises with her whistle reminded me of an overly excited chimpanzee.

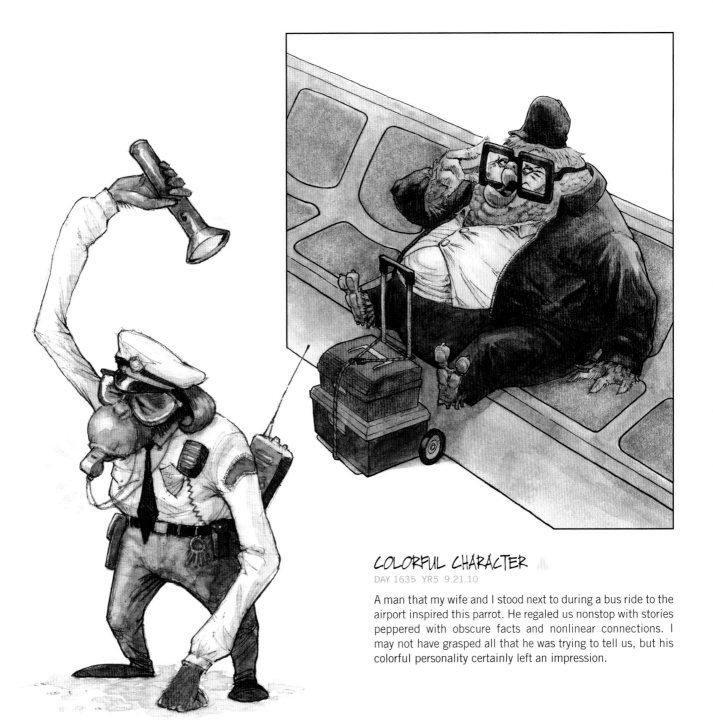

COLORFUL CHARACTER
DAY 1635 YR5 9.21.10

A man that my wife and I stood next to during a bus ride to the airport inspired this parrot. He regaled us nonstop with stories peppered with obscure facts and nonlinear connections. I may not have grasped all that he was trying to tell us, but his colorful personality certainly left an impression.

I'M NOT GOING ANYWHERE!

On some days the Daily Zoo characters are influenced by my mood at the time I draw them. Such was the case with this grumpy demon from Year Seven, though honestly I can't remember what I was feeling grumpy about that day. It must not have been that important after all.

SUNNING AT SUNNY'S

I may not remember exactly what inspired the grumpy demon, but I can specifically recall the circumstances that produced the relaxed moods of the two characters on the opposite page. The turtle was drawn on a sunny Sunday afternoon at a local neighborhood diner after my wife and I had enjoyed our turkey burger combos. She said, "Why don't you do your Daily Zoo now?" I replied that I wasn't really in the mood at the moment. "Well, what if you were to *draw* your mood right now. What would that look like?" Sitting there in the restaurant, bathed in the setting sun with a full belly after spending a lazy Sunday with my wife, I picked up my pen and proceeded to very quickly sketch this content turtle sunning on a rock. On the back of the drawing I scribbled the following:

"If you can find one moment each day to consciously be appreciative of that moment—and the many things that you are grateful for—then that is a moment well spent and a day well lived."

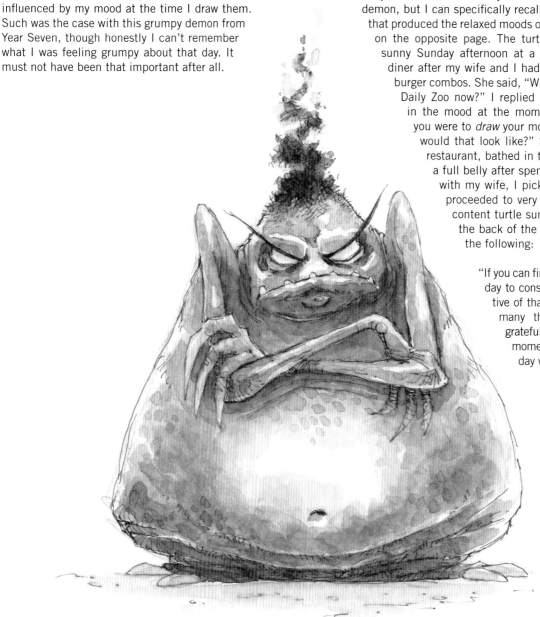

64

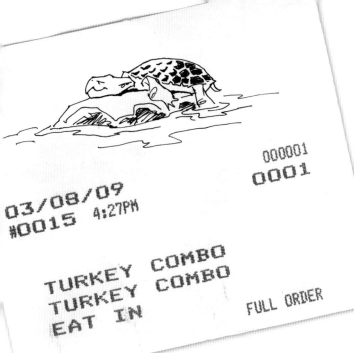

000001
0001

03/08/09
#0015 4:27PM

TURKEY COMBO
TURKEY COMBO
EAT IN FULL ORDER

CHEER-FULL
DAY 2451 YR7 12.13.12

This bear, caught in a moment of bliss, was done after attending a holiday party. It had been an evening full of good food, good wine, good people, and good cheer!

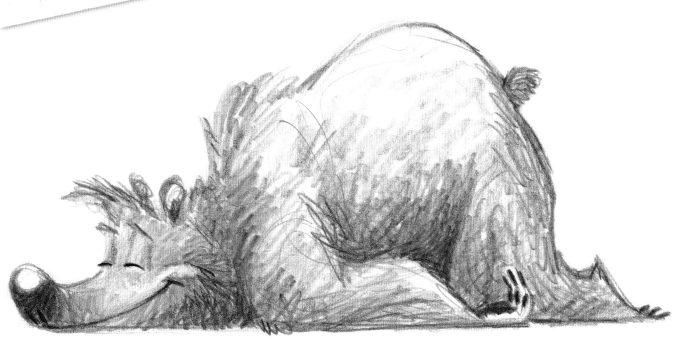

READY FOR WINTER ▶

On some days I take a day off from searching for inspiration altogether and ask somebody to name an animal to get me started. Some days I don't even have to ask—friends or family will just happen to suggest something. This was the case on Day 2692. We were having an open house get-together with my mom's side of the family in Wisconsin to introduce everyone to our eight-month-old son when my cousin Chris pulled me aside. He told me about a really, really fat squirrel ("I mean it was just *really* fat!") that he had seen running across the road on his bike ride that morning. Growing up in Minnesota I had seen my fair share of well-insulated squirrels in the fall months so I could envision what he must have seen. Chris said, "Maybe you could draw that sometime." So I did.

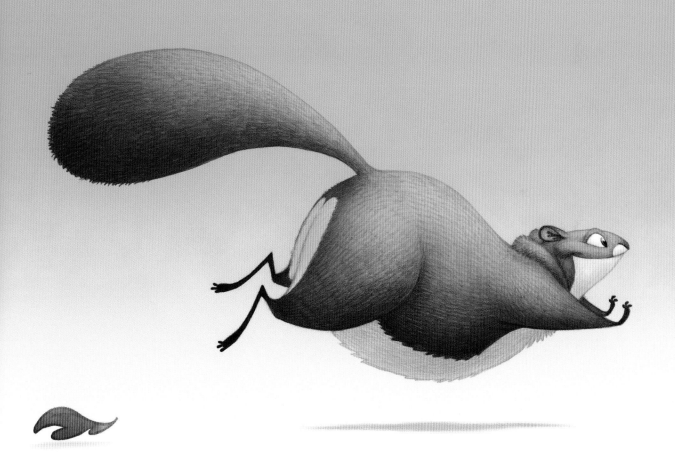

SOOTY SQUIRREL

Home for the holidays at my parents' house in Minneapolis in December of 2008, I had an encounter with a spritely visitor who came down the chimney. He didn't have a white beard or a red suit but he was definitely covered in soot.

It was late morning when I woke up and I knew that both my mom and dad were at work or off running errands. I should have had the house to myself so I was a little surprised when I heard activity downstairs, like someone shuffling objects on the dining room table. Maybe Mom had finished her errands early and was wrapping last-minute Christmas gifts?

I went downstairs and heard rustling among the decorative pine branches on the dining room mantle. It wasn't long before a wide-eyed face poked out from behind the branches. Sure enough, a squirrel had fallen down the chimney and was now scared out of his wits. This chimney visitor, however, did not leave any presents under the tree or in the stockings hung with care. The only "gifts" left were numerous pellet-sized ones scattered throughout the house.

A moment after seeing me the squirrel flew from the mantle and bounded through the other rooms of the house, frantically trying to regain his freedom. I quickly opened the front and side doors of the house, grabbed a broom, and proceeded to try to shoo him out—all the while in my boxers and a T-shirt on a subzero Minnesota day. Despite the fact that my powers of persuasion are much less effective on rodents than they are on people, I eventually convinced him that if he ran *away* from me and the broom, he would find his beloved great outdoors once again. Later I straightened up the things he had knocked awry around the house and cleaned up his "deposits." It was then that I discovered trails of sooty little paw prints crisscrossing the sofa. Ultimately this is what put the "cherry on top" in terms of inspiring the sketch of the day.

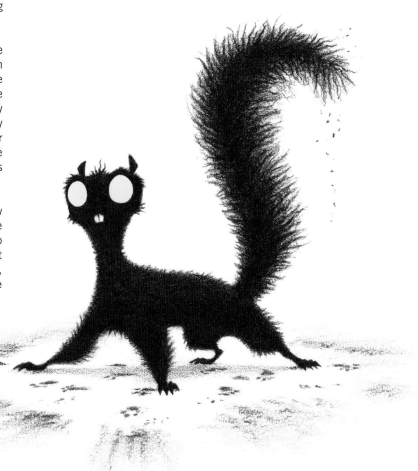

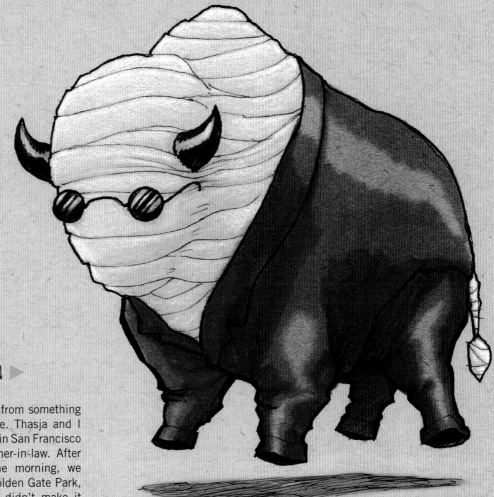

THE INVISIBLE BISON ▶
DAY 884 YR3 8.31.08

Today's inspiration came from something that *didn't* happen to me. Thasja and I were spending a weekend in San Francisco with my sister and brother-in-law. After exploring the city in the morning, we spent the afternoon in Golden Gate Park, though we unfortunately didn't make it to the park's Bison Paddock that we had read about. That evening my sister asked, "What's the animal of the day? The baby lobsters from Chinatown? The koi from the Japanese Tea Garden? The bison you didn't see?" Bingo.

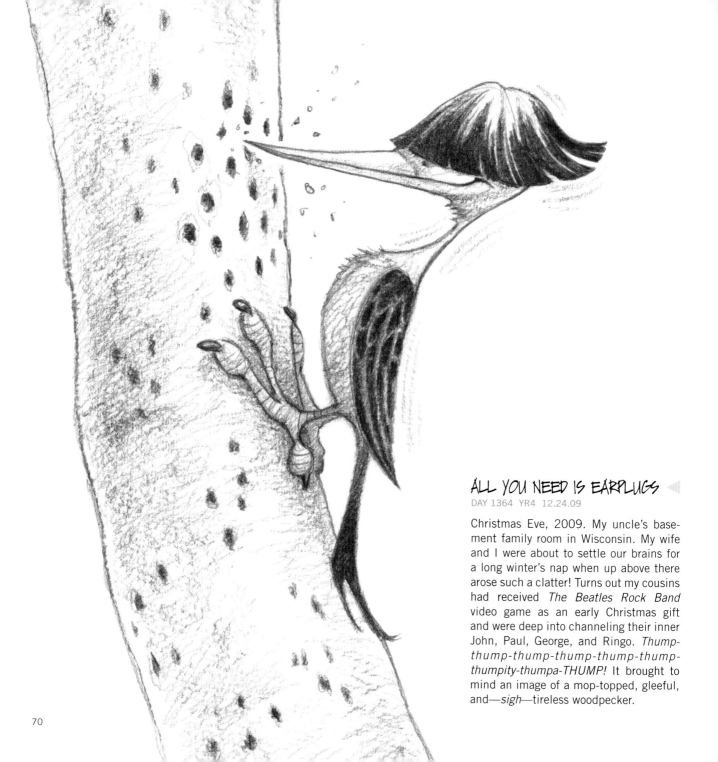

ALL YOU NEED IS EARPLUGS

DAY 1364 YR4 12.24.09

Christmas Eve, 2009. My uncle's basement family room in Wisconsin. My wife and I were about to settle our brains for a long winter's nap when up above there arose such a clatter! Turns out my cousins had received *The Beatles Rock Band* video game as an early Christmas gift and were deep into channeling their inner John, Paul, George, and Ringo. *Thump-thump-thump-thump-thump-thump-thumpity-thumpa-THUMP!* It brought to mind an image of a mop-topped, gleeful, and—*sigh*—tireless woodpecker.

STRANDED IN PHOENIX
DAY 1360 YR4 12.20.09

Before I could be kept awake by my cousins living out their rock star fantasies in the Midwest that Christmas Eve, however, I had to travel from Los Angeles. I made it as far as Phoenix before a mechanical problem with the aircraft interrupted the journey. Fortunately, the airline put us up in a hotel. Unfortunately, by the time the shuttle got us to the hotel and I got checked in, it was pretty late in terms of being able to find something to eat. There did not seem to be much within walking distance of the hotel but I set out anyway. Finding only a strip club and a gas station, I opted for the gas station's very limited à la carte menu and loaded up on chips, beef jerky, candy bars, trail mix, a giant pickle, and some soda. It was probably one of the least healthy meals of my entire life.

SPOOKED AARDVARK
DAY 1476 YR5 4.15.10

Sometimes my subconscious takes the steering wheel and provides the inspiration. This spooked aardvark appeared to me as I was drifting off to sleep the previous night. This happens to me fairly frequently but, unfortunately, I don't always remember what I saw. Perhaps these visions are the official welcoming committee of my dream state.

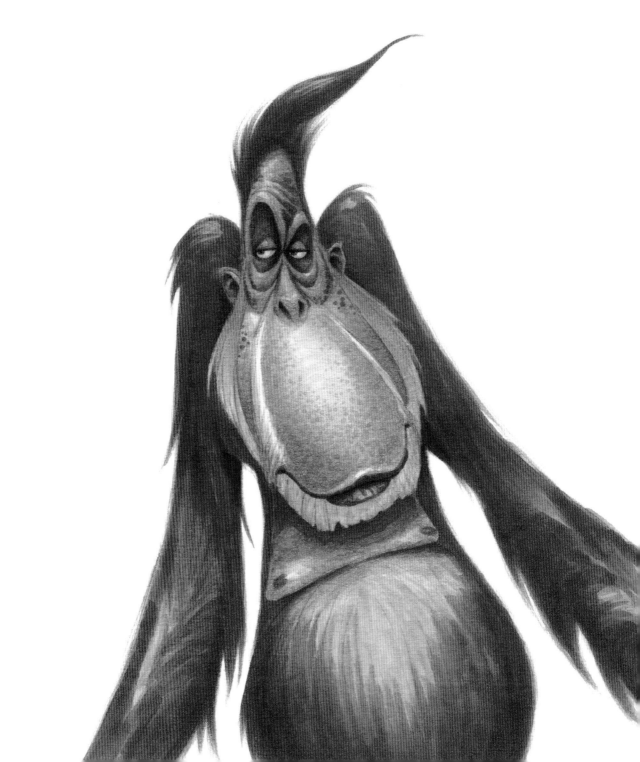

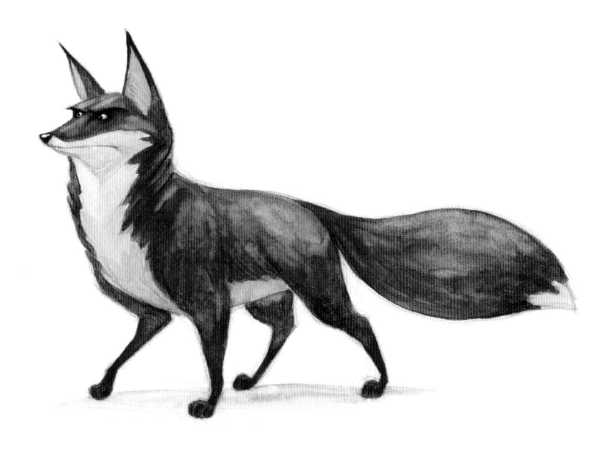

ORANGUTAN
DAY 2701 YR8 8.20.13

As mentioned at the beginning of this chapter, I find it important to remain observant of the world around me because inspiration can often arise from the most unexpected places. For example, it was a photograph of a tropical fish that inspired this orangutan. The photo was a top view of the fish and there was something about the silhouette and anatomical details that, when processed through the filter of my imagination, created a spark that eventually yielded the orangutan's elongated, pear-shaped head and wispy shock of hair. By using my imagination to see beyond what my eyes perceived I had the opportunity to meet one rather caricatured ape.

ON THE WATCH
DAY 900 YR3 9.16.08

After speaking to a class of art students on a return visit to my alma mater, St. Norbert College in Wisconsin, one of the students approached me and asked if I had ever drawn a fox. She went on to say that a relative was currently going through cancer treatment and that the fox had special meaning for her family. She didn't elaborate and I didn't press, but I did create this ever-vigilant, ever-watchful fox later that day with her in mind.

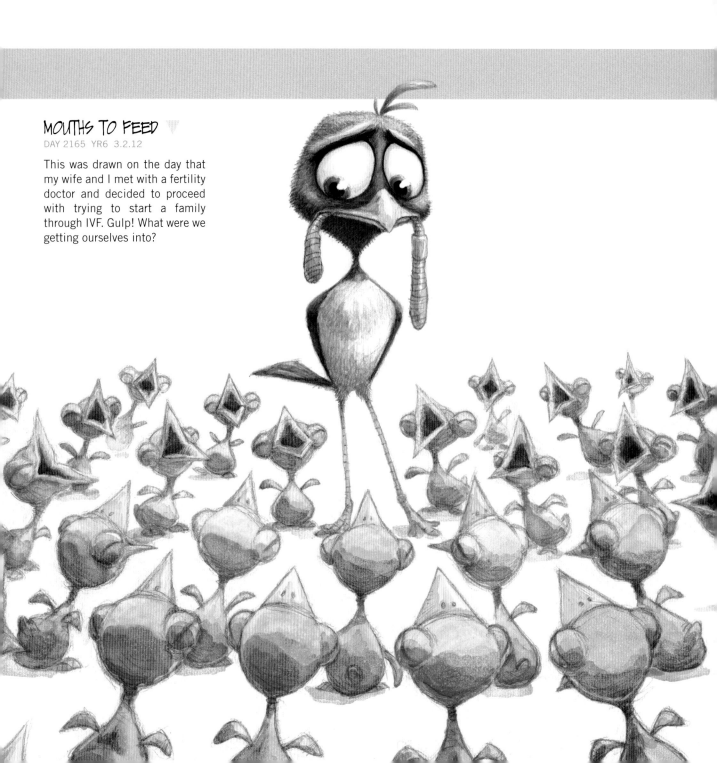

MOUTHS TO FEED

DAY 2165 YR6 3.2.12

This was drawn on the day that my wife and I met with a fertility doctor and decided to proceed with trying to start a family through IVF. Gulp! What were we getting ourselves into?

in vitro
we trust

Leukemia is indiscriminate, unforgiving, and treacherous. In short, it's one nasty beast. The lifesaving treatments I had, including high-dose chemo and total body radiation, were not much kinder. Besides the painful side effects, they left their mark by rendering me sterile. Fortunately my oncologist, UCLA's Dr. Gary Schiller, strongly recommended that I consider banking sperm before beginning treatment. He even delayed the start of my first round of chemo by a few days so I could do just that. My wife and I will be forever grateful to him, as the idea of banking was not even on our radar. I had just found out that I had cancer. I was not thinking about the possibility of never becoming a father. The idea of missing out on 3 AM diaper changings was the furthest thing from my mind. I just wanted to start fighting back against the leukemia as hard and as quickly as I possibly could.

Fast-forward seven years: I was in remission and feeling good. Thasja and I had gotten married and were now seriously considering thawing a few of the "man-sicles" we had on ice and trying to start a family. It was not a light decision by any means. Beyond the emotional, physical, and financial (ka-*ching!*) investment in the in vitro fertilization (IVF) process, we had to think about how this decision might impact our lives. With diaper changes come life changes. Were we ready for that? Were we prepared to make the required commitment of becoming parents and caring for a child? After much discussion, we came to the answer that I think had been buried within us all along. We just had to dig a little to unearth it. And that answer was, simply, "Yes." IVF? *Bring it on!*

A HAPPY SIGHT
DAY 2195 YR7 4.1.12

This was inspired by what we saw on the ultrasound screen a few weeks into the IVF process. We didn't actually see a face smiling at us, but the number and size of promising-looking ovarian follicles (each black blob hopefully containing an egg to be harvested) brought smiles to my, Thasja's, and our doctor's faces.

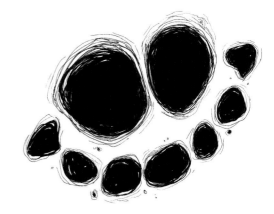

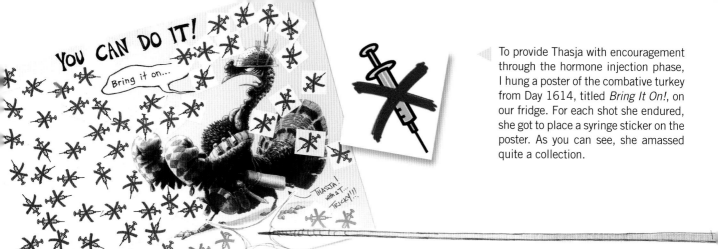

To provide Thasja with encouragement through the hormone injection phase, I hung a poster of the combative turkey from Day 1614, titled *Bring It On!*, on our fridge. For each shot she endured, she got to place a syringe sticker on the poster. As you can see, she amassed quite a collection.

CHARGE!

The IVF process is pretty miraculous and I tip my hat to the doctors and scientists who have worked hard to make it even possible, let alone discover the various advancements over the years. Unfortunately for my wife, one advancement yet to be discovered is how to bypass the necessity of the many, many hormone injections.

Thasja hates shots with a passion but was an absolute trouper. Each night for several weeks she'd let me jab her with multiple injections of the prescribed cocktails of medications and hormones. These would hopefully encourage her body to produce mature eggs that could then be harvested. The night before I drew this charging knight, I had given Thasja the all-important Trigger Shot in the upper-outer quadrant of her right buttock. This was to prepare her body for the egg retrieval procedure the following day. So for that night—and that night only, I might add—Thasja had every right to call me a pain in her a**.

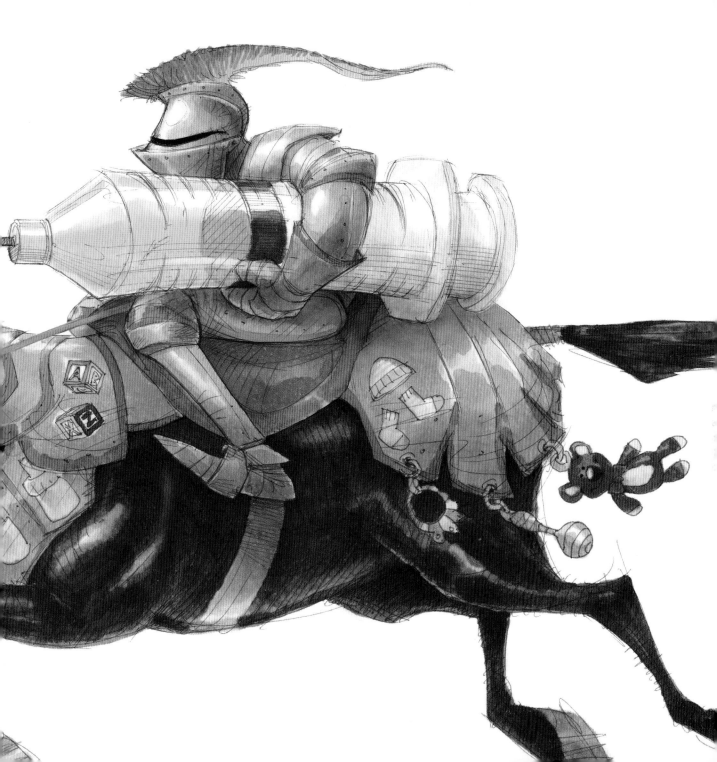

PRECIOUS

Thasja had her egg retrieval on this day. The bad news was that she woke up from the general anesthesia in quite a bit of pain. The good news was that the doctors had been able to harvest fifteen eggs, about the number they had hoped to retrieve. This supplied us with a temporary high and made the pain from the procedure, not to mention the discomfort from the hormone shots leading up to it, a bit more bearable.

Our high was relatively short-lived, however, when we found out the next day that only five of those fifteen eggs had successfully fertilized (only about half of what the doctors were hoping for). Perhaps it was an issue with the eggs or with the sperm, or perhaps there simply were no candles and violin serenades in the lab where the blind dates took place. Of course, in order to make a baby you need only one embryo, but there were no guarantees that any would grow enough over the next few days in the lab to be viable options for implantation.

It was a reminder of just how little control Thasja and I had over the outcome of the IVF process. So many intricate steps needed to happen before the actual pregnancy that we were on pins and needles a great deal of the time. *How were the follicles looking? Are we accurately measuring the injection medications as well as administering them correctly? How many eggs did we get? How many were fertilized?* Similar to other couples dealing with infertility issues, we were on high alert for weeks before the actual attempt at getting pregnant.

Today was the all-important embryo transfer. The weeks of preparation—all the shots, all the visits to the doctor—were all leading up to this point. Thasja and I were waiting in the exam room where the transfer would take place. We each had on sterile surgery caps and gowns, as if to signify our upcoming graduation from the IVF process. We were both nervous, and Thasja was growing more and more uncomfortable due to the fact that she really had to go to the bathroom. She couldn't, however, because the staff had told us that a full bladder was necessary to aid in the correct placement of the embryo during the transfer. Partly to try to

ease our nerves and to distract Thasja from her burgeoning bladder, and partly just for fun, I started playing with my very malleable surgery cap in the mirror, sculpting it into various "hats" and then acting out the corresponding character.

Of the five embryos that had fertilized only two had grown sufficiently to make the grade. Literally. Our doctor graded them and we were looking at two As, two Bs, and a C. (Thus ended our hopes of being IVF valedictorians.) It was agreed that the two As would be transferred. The embryologist went to the next room to make the final preparations and soon returned with a catheter loaded with hope.

The actual transfer was a bit anticlimactic and over very quickly. We watched the ultrasound screen as the flexible tip of the catheter was threaded into Thasja's womb. Once the tip had reached the optimal location (basically a uterine version of beachfront property), a quick squeeze from the doctor's fingers caused a small white glob to appear on the screen. And that was it. Done!

Now, it was time to wait.

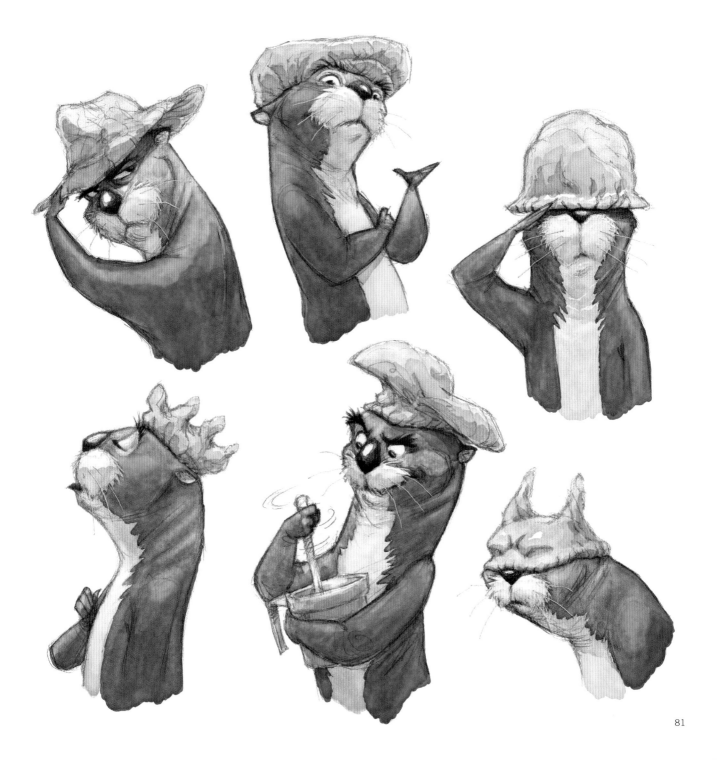

HOT DAMN, THERE'S A BUN IN THE OVEN!
DAY 2211 YR7 4.17.12

And wait we did. For twelve long days we tried going about our lives as normally as we could, though Thasja had been put on modified bed rest and told not to exert herself. There was nothing more we could do other than shower Thasja's belly with positive thoughts and words of encouragement to the little Bean. Finally the day arrived when our doctor could tell us if this whole process had worked. And it *had*. Thasja was pregnant!

We were relieved and grateful. Grateful that we had the means (barely) to be able to attempt IVF. Grateful to have a medical team that we trusted. Grateful that the process had worked on the first try. But, most of all, we were just grateful that it had *worked*.

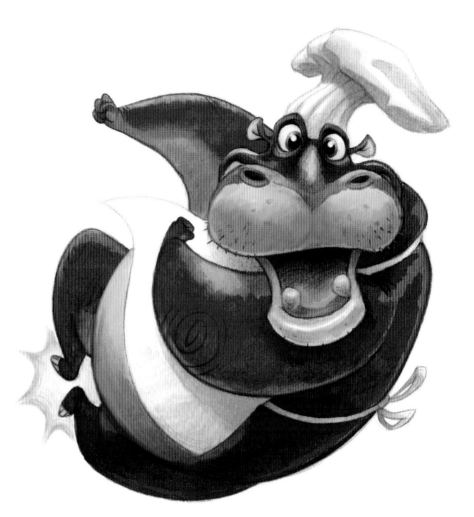

WAITING

Now that the wait to find out whether IVF had worked was over, we began a new kind of waiting: the Nine-Month Wait. The emotional roller-coaster still had us on board, however, as further challenges awaited, most notably six weeks of doctor-prescribed bed rest during the first trimester due to a possible placental detachment. But overall, things went relatively smoothly, and with each passing day we grew more and more eager to meet our little Bean.

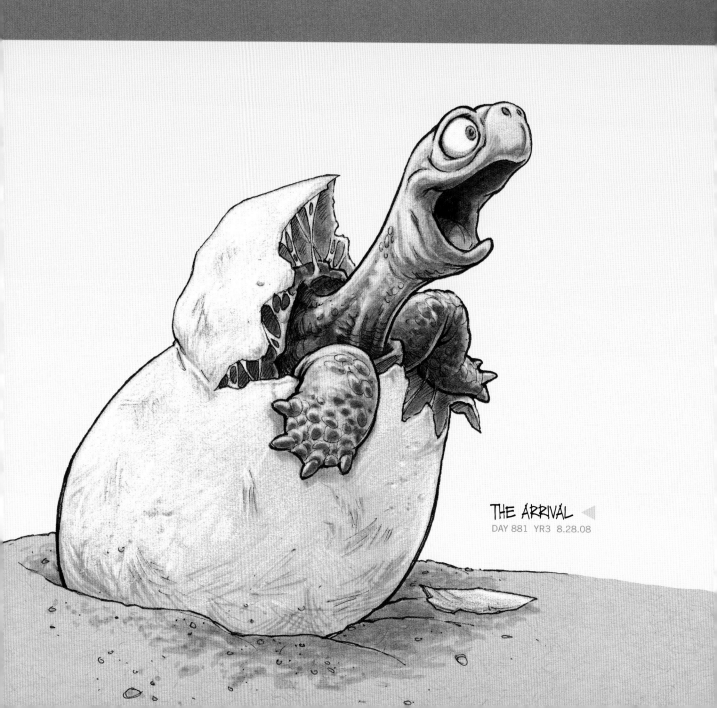

THE ARRIVAL ◄
DAY 881 YR3 8.28.08

the arrival
(or, *now* what?)

Looking back, the months of Thasja's pregnancy passed quickly. With amazement we watched her baby bump grow. Each successive ultrasound revealed a clearer picture of the little guy we were about to meet. What hit home the most for me was feeling him move, kick, and turn somersaults in my wife's belly. That tactile connection did more to make him seem real than any ultrasound image.

During the third trimester, we got busier with preparations for the Arrival. A cradle was acquired. Childbirth classes were attended. Breathing methods were practiced. Childcare classes were attended. Cloth diaper services were investigated. A section of my home studio was transformed into a nursery. A child CPR class was attended. And excitement grew. Through all of this I said, only half-joking, "I'm completely prepared...to be completely *unprepared.*" I believed there was no possible way that I could fully fathom what was heading our way. And for once I was right!

Originally expected to arrive on Christmas Eve (in a hospital and not down a chimney, we hoped) the little guy decided he had baked long enough and started to execute his exit strategy a week early. We happened to be at a holiday party and it was not long before Thasja mentioned she was feeling something a little... *different.* Soon a group was sitting around the fireplace, munching on Christmas cookies and trying to make small talk, but all in fact were more focused on timing Thasja's contractions than on anything else.

The contractions became much more intense once we got home. For the next several hours Thasja and I did a sort of Expectant Parent Waltz. In five- to seven-minute bursts of activity, we tried to accomplish last-minute tasks like packing for the hospital, doing laundry, and making mix CDs of soothing music for the delivery room. Thasja would call for me at the onset of each contraction and I'd rejoin her, encouraging her to breathe and hang on. Around 2:30 AM we left for the hospital. After the intense IVF process and nine months of cultivating our little Bean, it was finally—whether we were ready or not—*showtime!*

READY OR NOT, HERE I COME! ▼

DAY 2453 YR7 12.15.12

Despite our best efforts to heed the advice given in our childbirth class to not arrive at the hospital too early, we arrived...too early. Unable to be admitted until Thasja was further dilated, we set up camp in the empty waiting room, where I drew this cracking egg. Between pencil strokes, I held Thasja's hand and tried to help her breathe through the increasingly intense contractions.

HELLO, ZADEN!
DAY 2454 YR7 12.16.12

After hours of contractions, countless sharp inhales-exhales, and a very welcome epidural, it was time to push. Within twenty minutes and with one final push, we finally got to meet our son. He shot out into this world like a cannonball. Fortunately the doctor had good hands.

Wow.

Amazing. Stunning. Unbelievable!

To see and hear and hold that little guy, caused everything else to just fade away. Welcome to this party called *Life*, Zaden!

MAKING HIS PRESENCE KNOWN
DAY 2455 YR7 12.17.12

Once mom and babe were cleaned up, we were moved to a recovery room. Even deep exhaustion could not impede an overwhelming urge to hold Zaden. Thasja and I couldn't take our eyes away, studying his every feature and movement and soaking up the opportunity to begin getting to know him. One thing was certain: you didn't have to study him long to learn that he had a healthy set of lungs. We had our suspicions and several nurses confirmed as much.

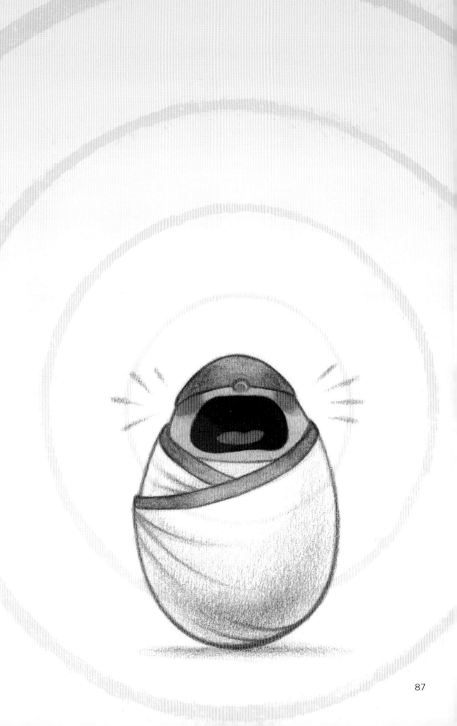

HOME

Two days after Zaden's arrival we came home, entering our house for the first time as a *family*. While Thasja and I were happy to be back in familiar surroundings, there was also a lot of trepidation. We no longer had the safety net of nurses and doctors just a few feet away. We were on our own!

To be honest, many of the details from that first night are hazy, thanks to an exhaustion-induced mental fog. I clearly remember, however, catching sight of my son and myself in a mirror after changing his diaper. It stopped me in my tracks. Holding this tiny bundle, I was seeing myself in a new light—a new role. It seemed as if I were trying on fatherhood in a fitting room at a clothing store. In that moment many of my fears and uncertainties, while not erased, were quieted because it just looked—and just *felt*—right.

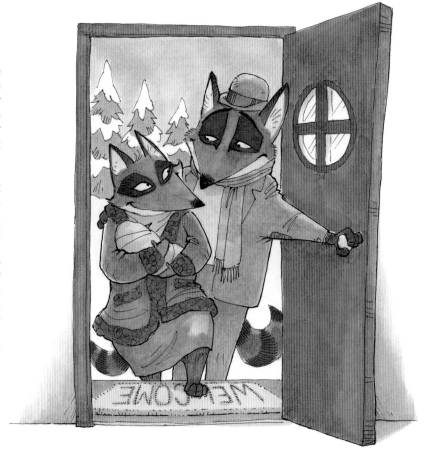

THE MORNING AFTER

That first night at home alone as new parents was pretty rough. As we feared—yet expected—our thirst for sleep went unquenched. The string of sleep-deprived nights and flood of emotions from the past few days, combined with the concerns and worries of first-time parents, had reduced us to barely-functioning zombies the next morning. But we made it!

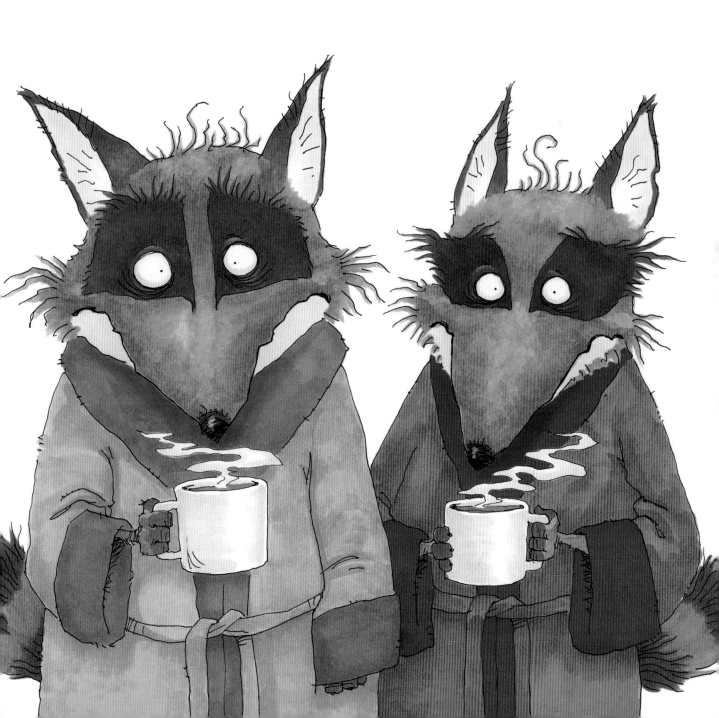

BABY'S FIRST BOTTLE

DAY 2476 YR7 1.7.13

We gave Zaden his first bottle on this day. He seemed to enjoy it...or at least tolerate it, which I equated to *victory!* It was a short-lived victory, however, as he didn't take many bottles after that. But I'm learning that in parenthood a victory is a victory regardless of size or duration.

Since this was our first go-round as parents, every "first" has a different flavor: the worry that accompanies that first unscheduled trip to the doctor...the uncertainty about how he'll take to that first bottle...the curiosity when giving him a new food for the first time...the adoration of the first time he puts his own feet in his mouth...and the excitement and joy for just about all the other "firsts."

CRADLE OF LOVE

DAY 2459 YR7 12.21.12

Our family portrait, drawn five days after Zaden's birth. We were already hopelessly in love.

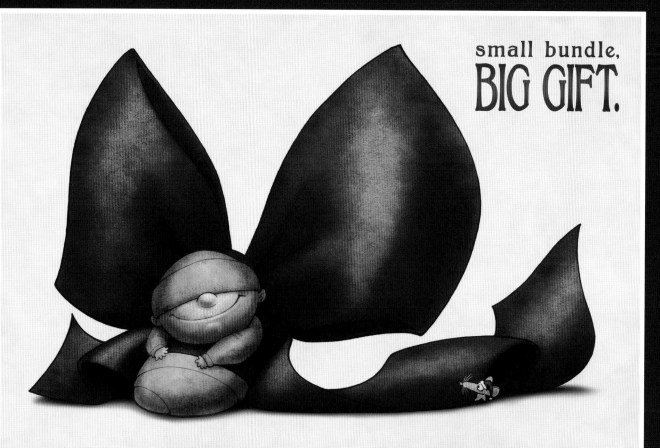

small bundle,
BIG GIFT.

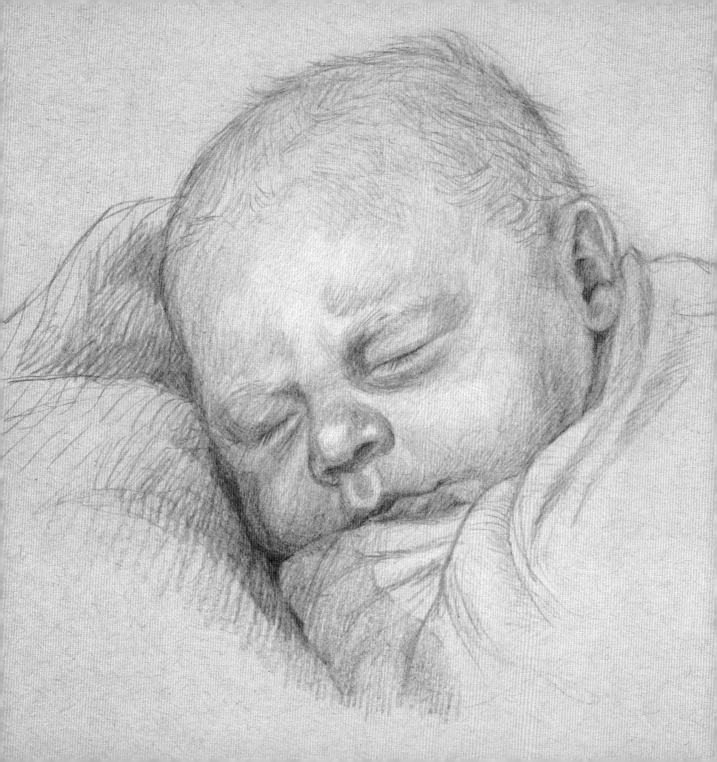

"SO, WHERE'S THE SNOOZE BUTTON?"

WHAT, NO SNOOZE?
DAY 2619 YR8 5.30.13

I sketched this one beneath a neon sign at the window counter of Pie Hole, a hoppin' pizza joint in downtown Boise, Idaho. I was in town to speak at a National Cancer Survivor's Day event hosted by Merina Healing Arts. The subject matter was inspired by a thought that had crossed my weary mind earlier that morning. Zaden had started to wake and I murmured, "Oh, Z...just five more minutes, dude...can you please just give me *five more minutes?*" Ha. No such luck.

The ironic part of doing this sketch while I was away on business was that I was going to be getting three nights of sound, uninterrupted sleep back at the hotel. I'm sure my wife was at least *slightly* envious.

LIKE FATHER, LIKE SON?

DAY 2642 YR8 6.22.13

I had Zaden and myself in mind when drawing this goose and gosling. Less than four months into parenthood I was already wondering what he might be like when he grows up. Who will he become? How will he be similar to his mother and me? In what ways will he be different? It wasn't concern, just curiosity. The sheer unlimited nature of the possibilities is exciting. I'm looking forward to the journey of getting to know him and watching him get to know himself.

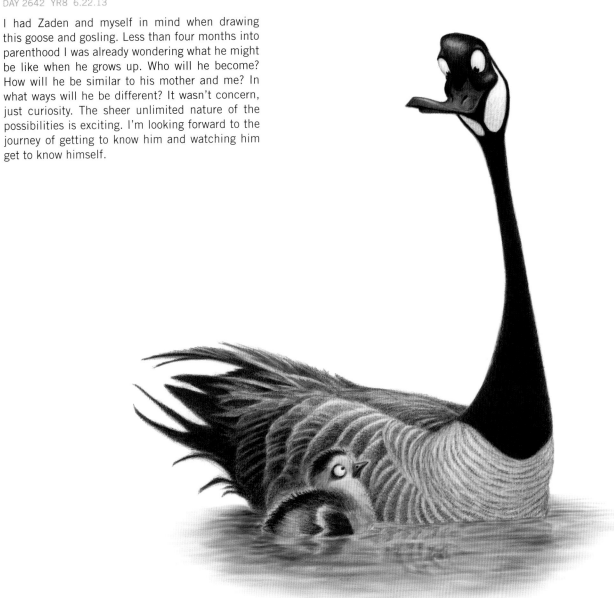

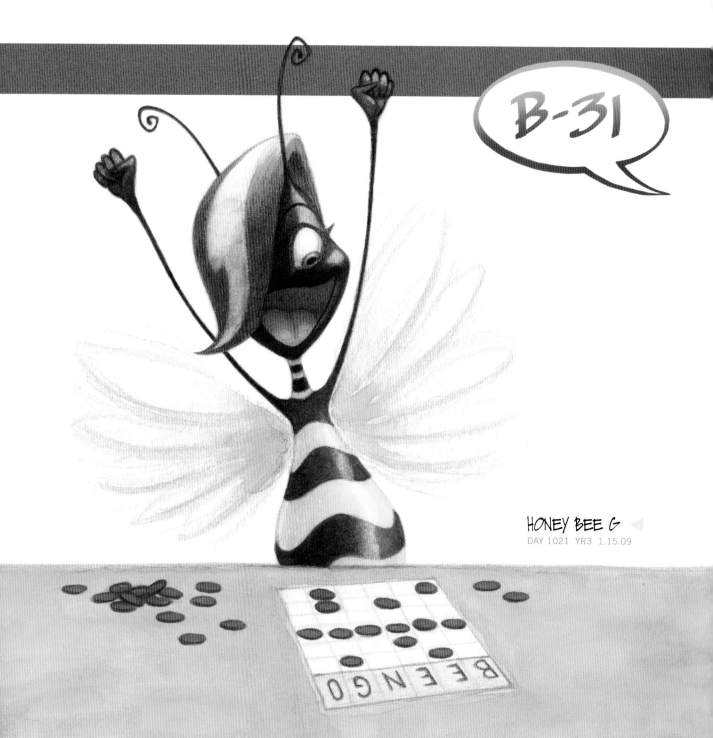

the daily zoo
& friends

One of the unexpected aspects of the Daily Zoo journey has been the interesting encounters it has brought my way, creating numerous opportunities to connect with people from around the world through my story and art. I was a bit naïve when the first *Daily Zoo* was published. Being a lifelong book aficionado, I was just so excited to see my work officially printed and bound that I didn't stop to think that people might actually read it!

I've come to realize that it's not all that important how much money we make. It's not so much either about what we do and what we accomplish. It's about the people we meet and interact with along the way. The lives we touch and those who touch our lives. Those we love and those who love us. Those who challenge us, both consciously and unconsciously, to be the version of ourselves that we would like to be. It's about the people we laugh with. The people who catch our tears and those who cry on our shoulders. In short, it's about shared experiences.

This chapter relates a few of the encounters that have either come about through the Daily Zoo or instances where the daily sketches have allowed me to honor and acknowledge relationships in my life.

The first example, one very excited bee, is shown opposite. It was inspired by Genese, a friendly desk clerk with a swoosh of fuchsia hair at the neighborhood post office. Her nickname was Honey Bee G. ("That's what everyone calls me at bingo.") During one visit she asked the routine, "Anything liquid, flammable, or perishable inside?" I replied that it was just artwork. "Your art?" she inquired. When I nodded she immediately asked if I would make her a calendar, without having any idea what kind of art I made. She then motioned to the blank wall next to her counter.

I could have laughed it off as a joke, but she was sincere and I admired her forthrightness. I don't know if she actually expected me to do it, but a few weeks later I brought her a Daily Zoo calendar. It took time to design it on the computer in addition to printing and trimming the pages before having it spiral bound. But it was worth the effort to see her reaction of surprise and appreciation. Plus, it was kind of a trip to see my artwork hanging in the post office every time I went to mail something. It was a neat opportunity to do something unexpected for a complete stranger. *The Daily Zoo* books may never top *The New York Times* Best Sellers list, but they have provided a rewarding journey rich in so many other ways.

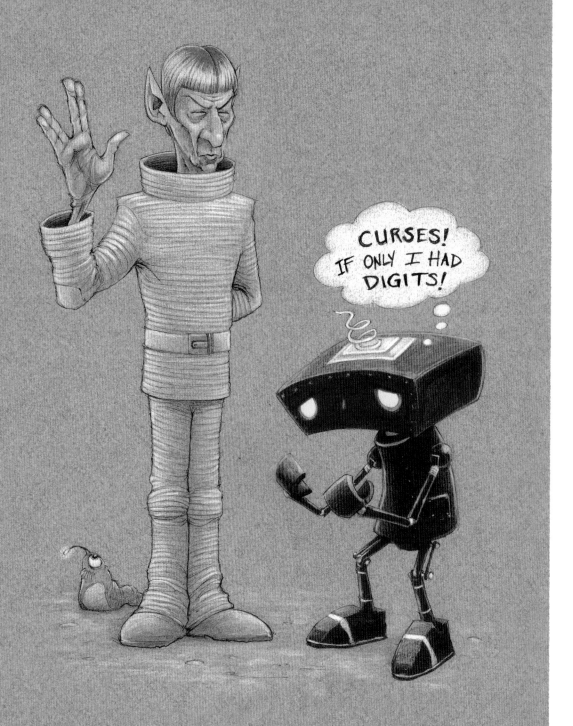

AWKWARD MOMENT
DAY 1719 YR5 12.14.10

I imagine that most of you are familiar with Leonard Nimoy's Mr. Spock from *Star Trek* and his signature "Live Long and Prosper" Vulcan salute. And if you are a fan of contemporary pop culture, there's a good chance that you are also familiar with this red robot. He's the mascot of Bad Robot, the production company of film director J.J. Abrams. I did this piece for J.J. not long after his reboot of the *Star Trek* franchise, as a long overdue "thank you" for so graciously giving his time and talent to write the foreword of all forewords for *The Daily Zoo, Vol. 1* (okay, so I might be slightly biased).

I was grateful to him for more than just his foreword, however. On the day before I was readmitted to the hospital for what I hoped would be my final round of leukemia treatment, I had the chance to briefly speak to J.J. after seeing him give a presentation on the visual effects of two of his TV series, *Alias* and *LOST*. For several years I had done cast caricatures of the *Alias* ensemble for him, and in our conversation he casually mentioned that he'd love for me to do one of the *LOST* cast sometime.

That final round of treatment—which included high-dose chemo, total body radiation, and a stem cell transplant—was by far the toughest for me to endure. During the times when I felt up to it, doing rough sketches and brainstorming ideas for a *LOST* caricature was a wonderful distraction from the nausea, needles, and mouth sores. J.J. couldn't have known this, but he had prescribed a creative outlet that proved to be a powerful painkiller. Thank you, "Dr." Abrams.

A PENGUIN FOR PATCH
DAY 1384 YR4 1.13.10

This clowning penguin was drawn in a copy of *The Daily Zoo, Year 2* that I gave to Dr. Patch Adams. I became acquainted with Patch when I asked if he would consider writing a blurb for the first *Daily Zoo* book. Despite his busy schedule, he kindly agreed. As the Daily Zoo has increasingly and wonderfully made my life busier, I have gained an even greater appreciation for Patch and J.J.'s contributions. With each of them being exponentially more renowned than my Zoo, I am aware of how precious their limited time must be and how generous they were in sharing some of it with me. It's something that I try to keep in mind when *Daily Zoo* readers make requests of my time.

BRINDLED CHELK

After the publication of *The Daily Zoo, Vol. 1*, I began exhibiting at various book festivals and conventions. Not only are these venues a great forum to introduce people to my story and artwork, they have also been a way to meet other exhibiting artists and authors, some of whom have become close friends over the years. One such artist, the talented Dean Yeagle, suggested that I do a "brindled chelk" for my animal of the day sometime. I liked the sound of it but had to run to my animal encyclopedia, as I had never before heard of a brindled chelk. Given my lifelong interest in animals it is a rare occurrence to come across a species that is new to me. I was relieved to learn that I was not ignorant and uninformed after all (at least not in this case), since it turned out that Dean was pulling my leg: there is no such thing as a brindled chelk.

That changed with Day 1381.

THE SMARTEST DODOS I KNOW

Two very close friends of Thasja's and mine, Sean and Garth, loosely inspired these two dodo birds. I should clarify, lest they read this and become very close *former* friends. It's not that they remind me of "dim-witted dodos," a reputation the species had gained because they were so easy to catch (which ultimately played a role in their extinction at the hands of humans). In fact, when I began the sketch I wasn't even thinking of Sean and Garth, even though we had just had dinner with them.

It started with just one dodo but then turned into two. Somewhere during the sketching process the idea occurred to loosely base them on our friends. I liked the idea of two buddies who complemented each other's personalities well. Sean is perpetually enthusiastic. Garth is quick-witted and dispenses his dry humor in Tommy-gun–like fashion. Put the two of them together and you are in for an entertaining evening, especially if they choose to regale you with meticulously detailed stories about their spontaneous expeditions to places like Tijuana and Las Vegas.

When I lost my hair from chemo, Sean and Garth showed up at the hospital one evening as bald as me, having shaved their heads in solidarity. And both played important roles at our wedding: Garth being the officiant and Sean playing guitar. They may certainly be birdbrains at times, but Thasja and I could not think of two better dodos to have as honorary uncles to our son.

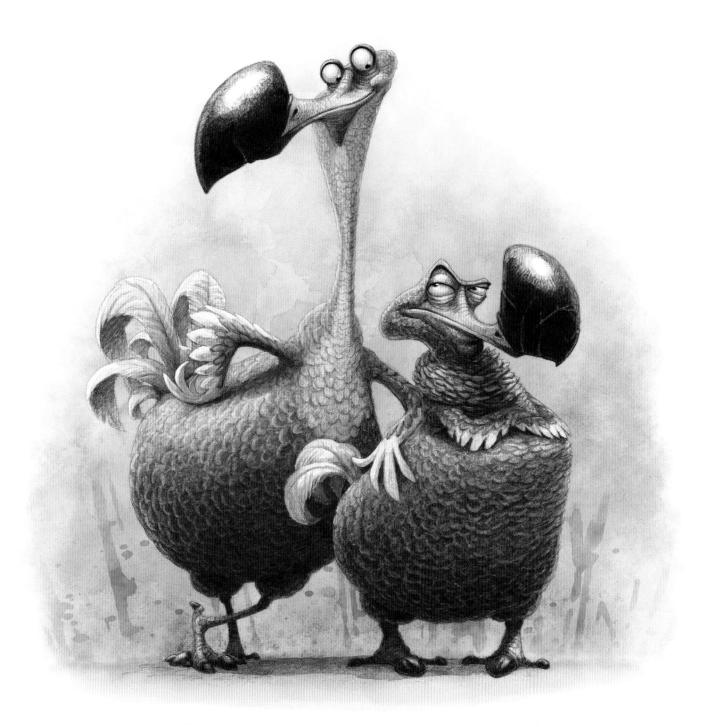

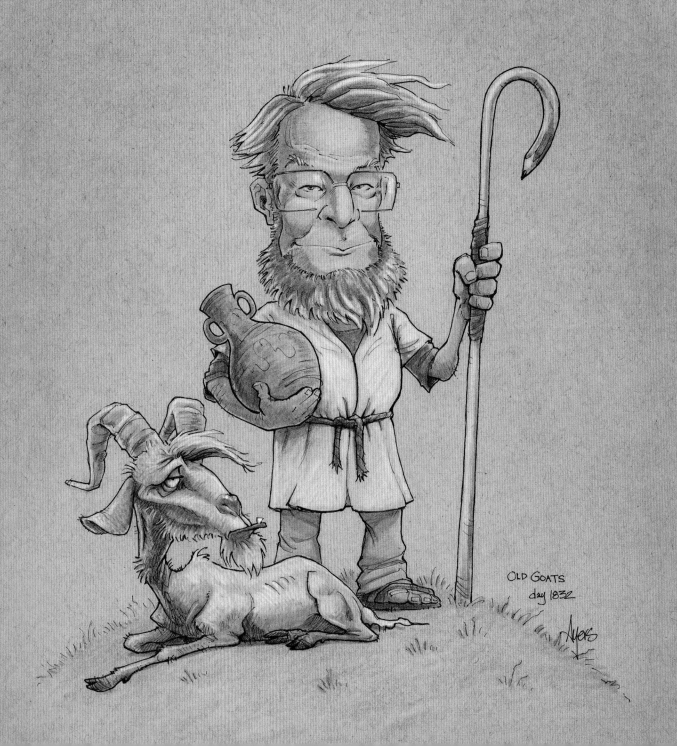

OLD GOATS
day 1832

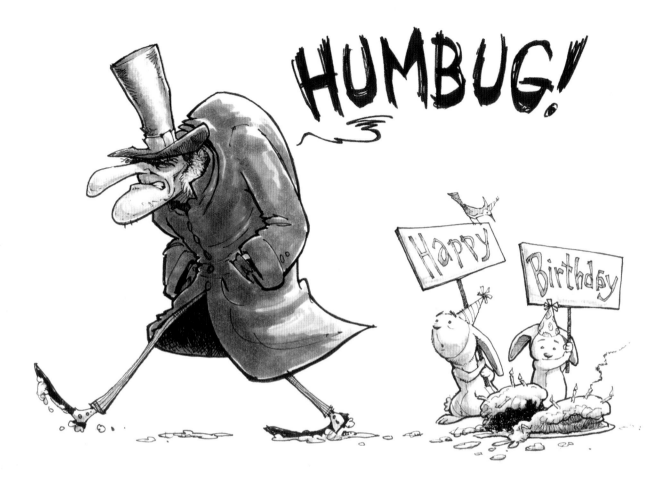

OLD GOATS
DAY 1832 YR6 4.6.11

This was a gift for one of my college art professors. After more than 40 years as a higher education academic, Donald Taylor—or Donaldo, as I came to call him, as he was among those who encouraged me to study abroad in Italy for a semester—was retiring. He had invited me back to campus for his retrospective exhibition and retirement festivities. I drew him as a shepherd because he watched over a large flock of students throughout his lengthy career. I'll always be grateful for the many opportunities to artistically challenge myself that he provided as well as his guidance along the way. *Grazie mille, Donaldo!*

HUMBUG!
DAY 1417 YR4 2.15.10

The Creative Talent Network, an organization of artists and animators based in Burbank, California, was putting together a birthday sketchbook for the legendary British artist, Ronald Searle, and was inviting its members to contribute their own birthday wishes. Having been influenced by his edgy designs and wit, I jumped at the chance. I chose a Scrooge theme since one of Searle's many well-known works was an animated version of *A Christmas Carol*.

WONDER NO MORE
DAY 1286 YR4 10.7.09

Another convention acquaintance of mine, esteemed comic book artist Aaron Lopresti, asked me to fill a page in a sketchbook he had brought to Comic-Con in 2009. This was no ordinary sketchbook, however. Over the years Aaron had been asking various artist friends and colleagues to make a page their own. It was quite the collection: Bruce Timm, Mike Mignola, Jim Lee, Peter de Sève...I would be in phenomenal company. Talk about pressure! I ended up doing this brutish crocodile, and since Aaron was working on the *Wonder Woman* comic book at the time, I decided to depict him moments after enjoying a Wonder-ful snack.

HORSE WITH LIPSTICK
DAY 1059 YR3 2.22.09

While visiting dear friends of ours in Carlsbad, young Isabella (age five) drew a horse for me for Valentine's Day. Her older brother, Maxwell, exclaimed, "Is that LIPSTICK?! Horses don't wear lipstick!"

"Really?" I replied, "All the horses I've ever seen wear lipstick." I applauded her unabashed creativity and imagination. Plus, drawing a horse with lipstick just sounded like *FUN!* And it was, as I discovered later with my sketch of the day. Isabella had the right idea.

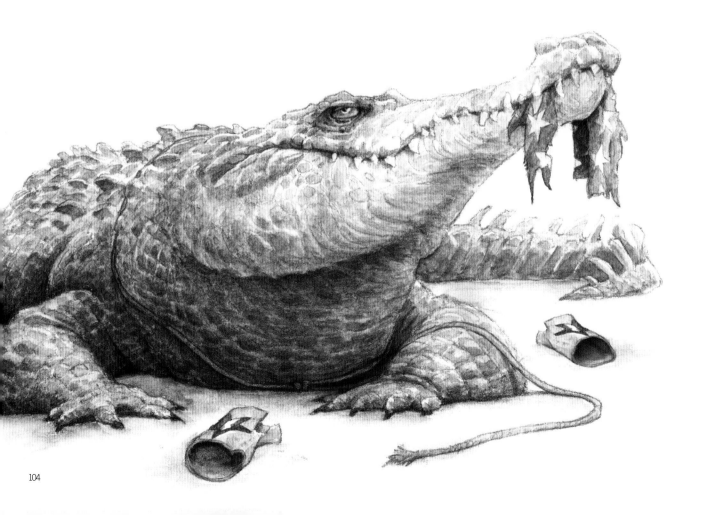

Horse with Lipstick by Isabella, age five

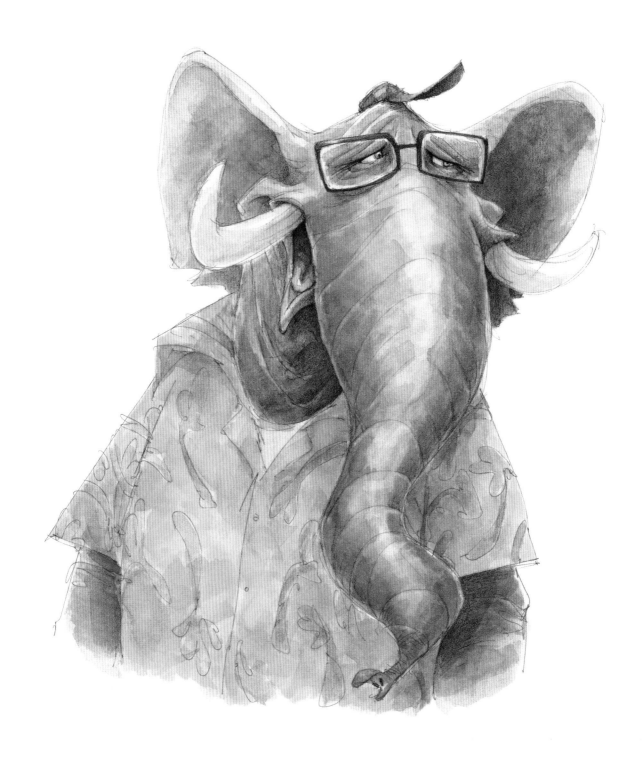

FRED THE FRIENDLY

DAY 2354 YR7 9.7.12

In late summer of 2012 I received a kind email from Dr. Fred Frye, former president of the San Diego Zoo. He had read my books and mentioned that he was a fan of *The Daily Zoo*. When I told him that my wife and I were huge fans of *his* zoo, widely regarded as one of the best in the world, he graciously invited us down for a behind-the-scenes tour. It was a real pleasure spending the day with Fred and his wife, Joy, not to mention having amazing up-close-and-personal encounters with jaguars, tigers, elephants, and giraffes.

I kept Fred in mind when I drew the day's sketch. Physically, he's an imposing guy, yet I got the impression that he's a gentle soul. Both of those qualities reminded me of the bull elephant that we had fed celery to that afternoon. (Notice the pattern on the shirt?)

"WALKING" THE DOG

DAY 1534 YR5 6.12.10

This was done as a birthday gift for Scott Robertson, a friend, mentor, and founder of the publisher of this book, Design Studio Press. His wife, Melissa, had previously shown me a photo of their imaginary pet: a Danish-Swedish farm dog. She told me they didn't have a dog but if they did, it would be this one and his name would be Sprocket. If you are not familiar with Scott's artwork, he is perhaps most widely known for his intricate and original vehicles and spaceships. If Scott had a dog, I wouldn't be surprised if this were how he would "walk" him.

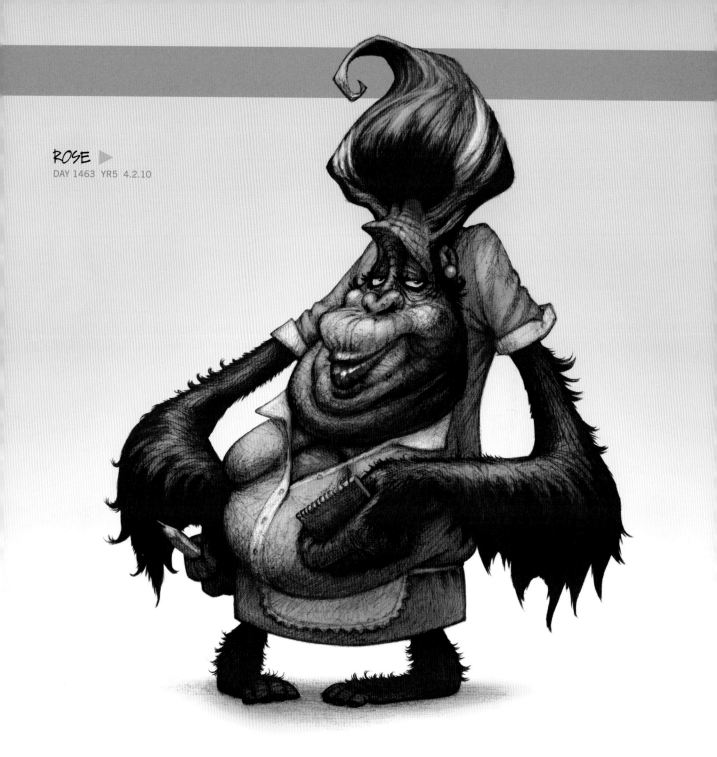

getting into character

So what does a character designer do? Basically, he or she gives visual form to a character that exists only as words in a script or thoughts in a director's head. It is the character designer's job to transform these descriptions into artwork that is appealing, frightening, heroic, villainous, adorable, or whatever the story may require. The best characters, in my opinion, should ooze story. This is often accomplished through the use of interesting underlying shapes that compose a character's silhouette, intriguing costumes and props, and certainly through facial expressions and body language. The entire details of their story need not be apparent, but the *presence* of an interesting story *should* be. Doing research and gathering appropriate reference material can help in regard to adding richness and believability to a character.

When designing characters I try to go beyond the sheer physical attributes of the subject matter. To me animals are not merely animals, not simply arrangements of flesh and bone, fur and feathers, antlers and antennae. They are so much more. I think of them as individuals with distinct personalities, experiences, and likes and dislikes. Each lioness, for example, has her own story. This approach certainly applies to human characters as well. That's not just a man waiting for the bus. He's a husband…a father…and maybe even a stockbroker who dreams of being a circus clown.

How does one design characters with story in mind? Well, I attempt to get inside each character's head. Walk in his shoes for a mile. Wear her stripes for a weekend. Slither around on its tentacles for a day. Basically, I try to *become* them. I act them out, sometimes in a mirror but at least in my head. The more fully I *know* them—the more I can bring them to life in my mind's eye—the easier it is for me to make design choices on paper. (That seahorse would *never* wear dark gray because she would think it would be an affront to her perpetually sunny demeanor.)

I make a concerted effort to bring as much expressiveness to my characters as I'm able. I try hard to make that badger, yellow-bellied sapsucker, or pickle deliveryman as intriguing as possible. Ideally that design will pique the interest of the viewer and leave him or her wanting to know more. Successful characters should be relatable on some level, both story-wise and personality-wise, but also visually.

Most of what I have mentioned above I have learned throughout my career and I believe them to be sound theories. But beyond these, I also let my inner child guide my designs, especially when I have more creative freedom while designing for my own projects. I try my best to come up with something that I would have liked as a kid, be it scary, funny, cute—or just plain *cool*.

SIR DESMODUS ROTUNDUS

DAY 1537 YR5 6.15.10

Dracula is often depicted as a clean, dapper, elegant creature. He is, after all, a Count. I wondered, "Would some of that elegance still be apparent when he takes his bat form?"

THE INVESTIGATORS

DAY 1806 YR5 3.1.11

The investigative duo of Hammer & Lomax, a gecko and an echidna respectively, are the bane of criminals and evildoers throughout the entire Steel City metropolitan area. With Lomax's brains and Hammer's brawn, they are the P.I.s of choice when the numbers just don't add up.

This drawing was sketched very quickly and loosely, which serendipitously played a role in not only the look of the piece but also its content. When I started, I was planning to draw only one character, not two. One of the first strokes was the downward swoop of the hat brim. Not sure of what animal or type of character he was going to be, I worked my way around the body before coming back to the head and face. A quick flick of the wrist added the long snout and solidified his existence as an echidna (a spiny anteater marsupial from Australia and New Guinea).

There was a fairly large gap to fill between the hat and the coat collar, but I liked the idea of having the echidna's eyes bulge out of the top of his head. Rather than filling the space with skull and fur and echidna quills, I added Hammer the gecko, gently lifting up the hat to reveal himself. That turned the solo private investigator into a duo and, in turn, led to a much more interesting backstory.

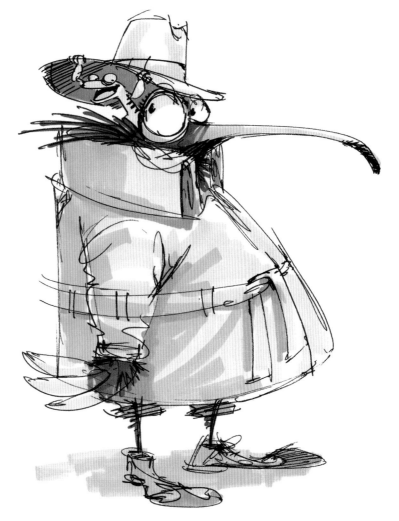

SNOTTWEILER

I had been dealing with a cold and did not yet have an idea for my daily sketch. Inspiration was found, however, by blowing my nose vigorously before starting to draw.

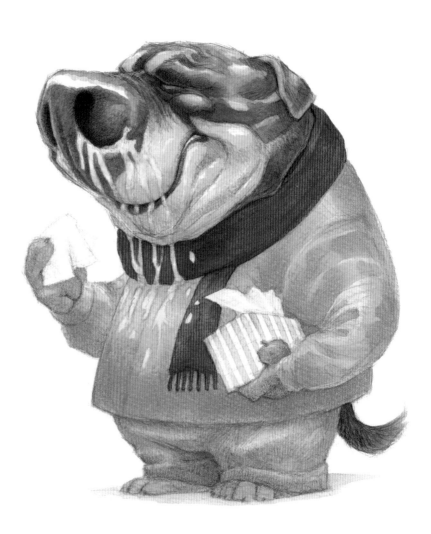

My wife ran twenty miles today as part of her training for the Chicago Marathon. While I love the idea of running a marathon myself, I was happy to simply be her refreshment and rejuvenation station at miles twelve and sixteen. *My* marathon is the Daily Zoo.

TIGER IN TAILS ▶
DAY 830 YR3 7.8.08

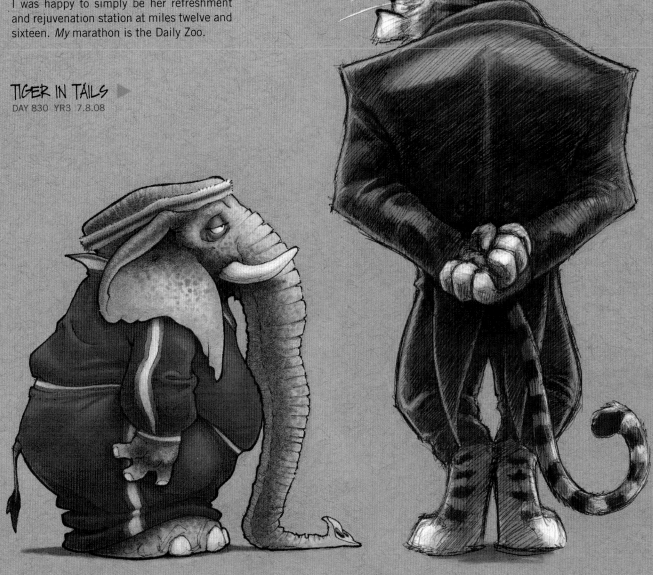

PRINCELY PIGEON ◀

I had the larger-than-life musician Prince in the back of my head while drawing this one.

IN-VESTED REX
DAY 2222 YR7 4.28.12

BERTRÁM HONEYCOMB
PREPARES FOR HIBERNATION
DAY 2722 YR8 9.10.13

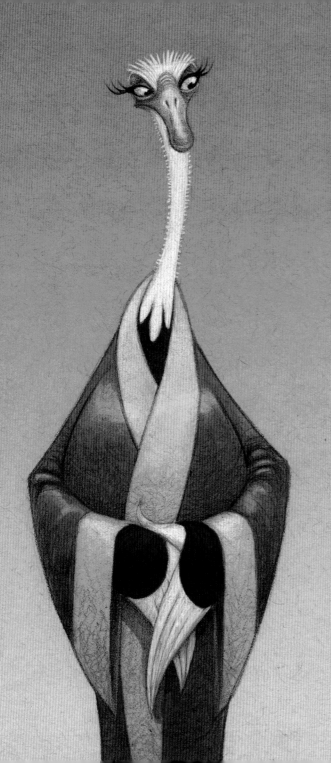

SENSEI ◀
DAY 888 YR3 9.4.08

PHILLIP THE BLACK-FOOTED FERRET ▼
DAY 2727 YR8 9.15.13

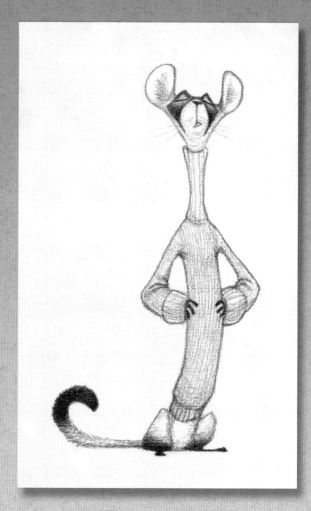

REX AND HIS MASTER

A character rarely exists in a vacuum. Most are often part of a larger cast, which is helpful to keep in mind when designing them. Visually they should all look as though they inhabit the same world and they should share the same design style—unless the story specifically dictates otherwise. When I'm designing a character for a project I also like to imagine him or her interacting with the other characters in the story. How would your protagonist react to the feisty hedgehog bent on revenge? How would he console the distraught princess whose fiancé has just asked her to sign a prenup? Envisioning these scenarios, whether hypothetical or from the actual script, enables me to get a better sense of who it is I'm trying to design.

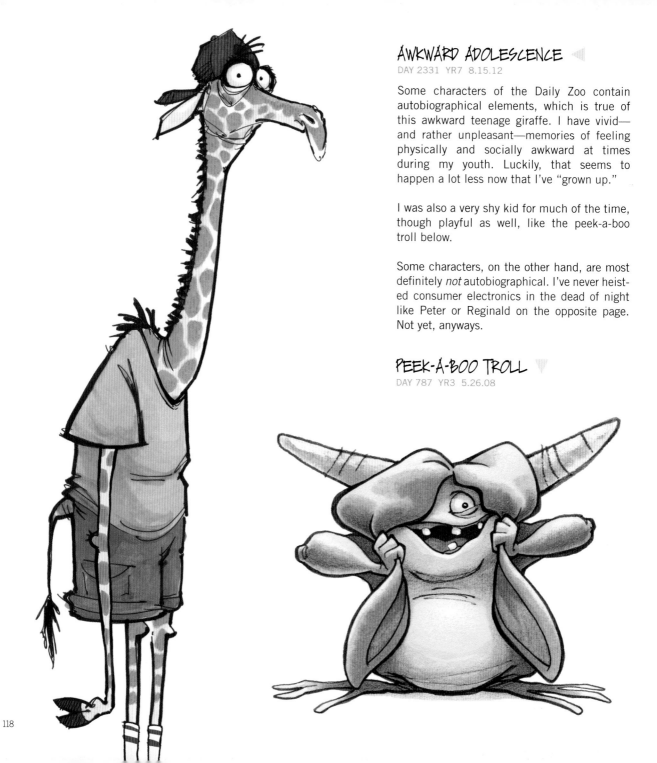

AWKWARD ADOLESCENCE
DAY 2331 YR7 8.15.12

Some characters of the Daily Zoo contain autobiographical elements, which is true of this awkward teenage giraffe. I have vivid—and rather unpleasant—memories of feeling physically and socially awkward at times during my youth. Luckily, that seems to happen a lot less now that I've "grown up."

I was also a very shy kid for much of the time, though playful as well, like the peek-a-boo troll below.

Some characters, on the other hand, are most definitely *not* autobiographical. I've never heisted consumer electronics in the dead of night like Peter or Reginald on the opposite page. Not yet, anyways.

PEEK-A-BOO TROLL
DAY 787 YR3 5.26.08

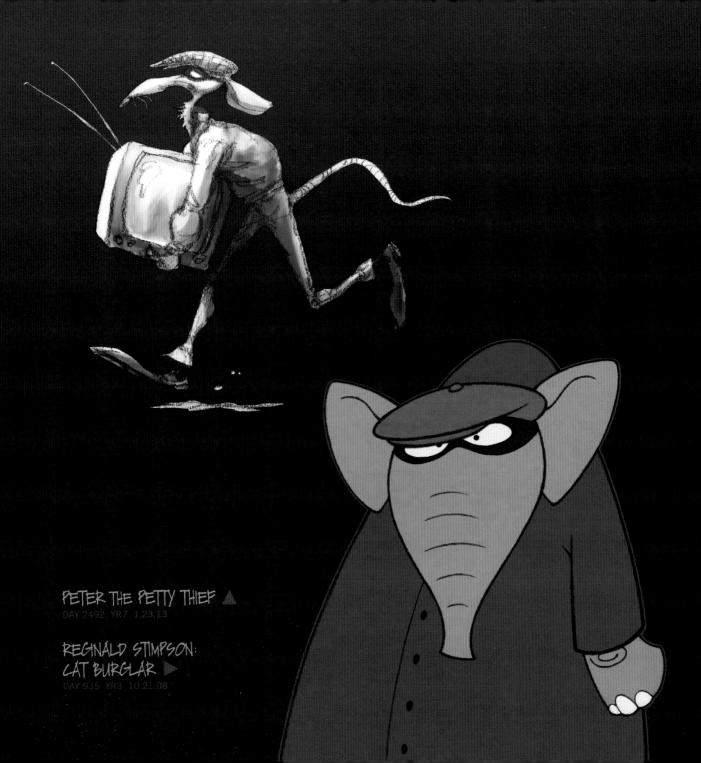

PETER THE PETTY THIEF ▲
DAY 2492 YR7 1.23.13

REGINALD STIMPSON:
CAT BURGLAR ▶
DAY 935 YR3 10.21.08

OCTOPIRATE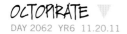

In hindsight I regret giving this octopirate only one sword. I mean, *come on!* A pirate with EIGHT capable swashbuckling "hands" and only ONE sword? What a missed opportunity!

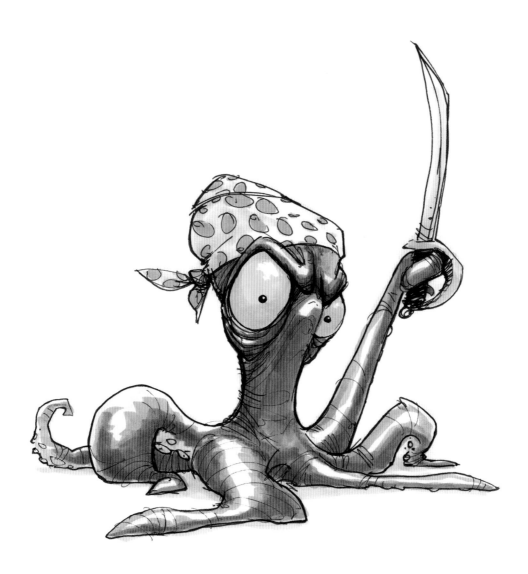

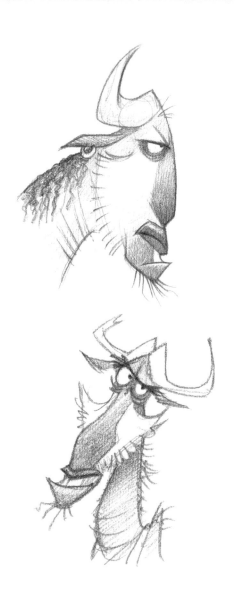

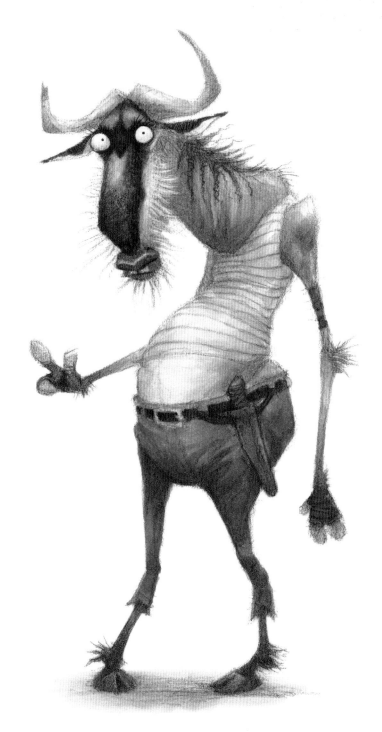

FIRST MATE JIBBS

DAY 2994 YR9 6.9.14
DAY 3005 YR9 6.20.14
and DAY 3006 YR9 6.21.14

Little known fact: wildebeests
are surprisingly seaworthy.

MORTY THE MOUSE...
ON A MISSION! ▲
DAY 2370 YR7 9.23.12

RINK RAT ▶
DAY 918 YR3 10.4.08

Glenda the Glide was drawn after attending a roller derby for the first time with some friends. We all enjoyed the lively energy of both the competitors and the crowd. So much so that for a while my wife was seriously considering trying out for the league—which then entertained us as we brainstormed what her "rink name" would be...Thasja the Tank? Thunderbolt Thas? Trainwreck T?

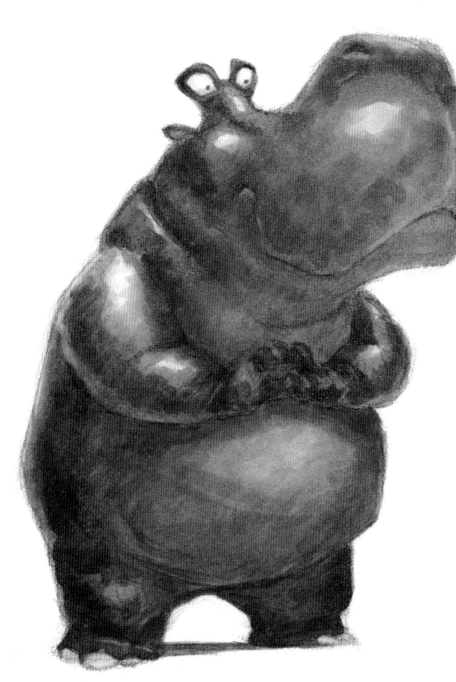

IN ANTICIPATION
DAY 2991 YR9 6.6.14

Instilling a character with great…
well, *character,* doesn't necessarily
require adding things like costumes
and props, though they can certainly
be helpful at times. So much can
be communicated through facial
expressions and body language. The
subtlest positioning of an eyelid or a
slight turn of the hips, for example,
can go a long way in bringing further
character to your designs.

It all boils down to that spark of
life, which can be difficult to define
and sometimes even more difficult
to realize. Ultimately as a designer
I have to completely believe in my
characters if I have any hope of
audiences doing the same.

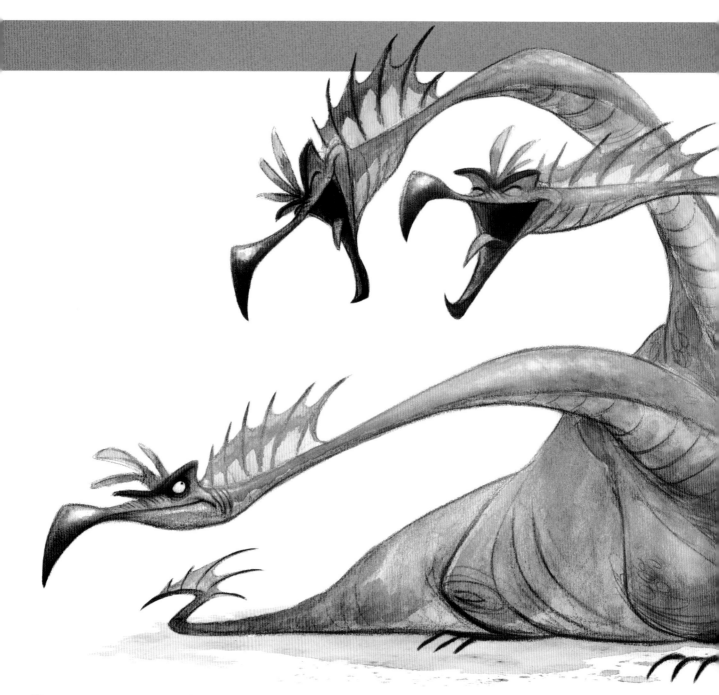

odds 'n' ends
(but heavy on the odd)

While many of the Daily Zoo images featured in this book fit nicely into chapters based on certain themes, my imagination—and thus my drawings—are not always so focused and organized. In fact, it is often the opposite. One of the nicest things about keeping a sketchbook is that it can be completely random and obscure. A sketchbook is the perfect receptacle for fleeting thoughts and observations, an outlet for the runaway trains and non sequitur tsunamis of one's imagination.

To be sure, the Daily Zoo sketchbooks—with their premise of drawing an animal each day—are a bit more focused than some of the other sketchbooks I have kept, but each blank page still holds a great deal of surprise. I rarely know what's going to happen when I pick up the pencil…and that's what I love about it! So with that, I invite you to turn the page and take in a little bit of this, a little bit of that, and a whole lot of *odd*.

ODD MAN OUT
DAY 2465 YR7 12.27.12

If you happen to have multiple heads, I hope you all get along.

MERMAID?

DAY 2447 YR7 12.9.12

Why is it that mermaids are always depicted with the top half of a woman and the bottom half of a fish?

TREE FROG

DAY 1466 YR5 4.5.10

BATHTIME FOR GIL

To raise funds for cancer research as well as to keep fit, my friend Mike competes in various marathons, bike-a-thons, and triathlons through the Leukemia & Lymphoma Society's Team in Training program. On this particular day he had invited me to exhibit *The Daily Zoo* books at a fundraising event that he and his teammates had organized. While signing a book for Mike—who is also an avid fan of *The Creature from the Black Lagoon*—I loosely sketched a more domestic version of a gillman. Liking the concept, I did a more polished version for this day's sketch.

AYE-AYE

DAY 734 YR3 4.3.08

Aye-ayes are nocturnal, arboreal lemurs found only on the island of Madagascar. They use their extremely long third finger for "percussive foraging," a technique of tapping on tree branches to find wood-boring grubs. This specialized digit is then used to extract a tasty and nutritious meal—tasty, that is, if you're a nocturnal, arboreal lemur on the island of Madagascar.

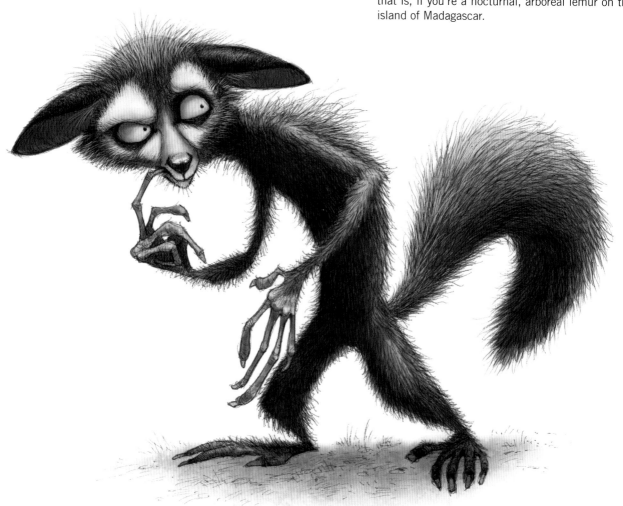

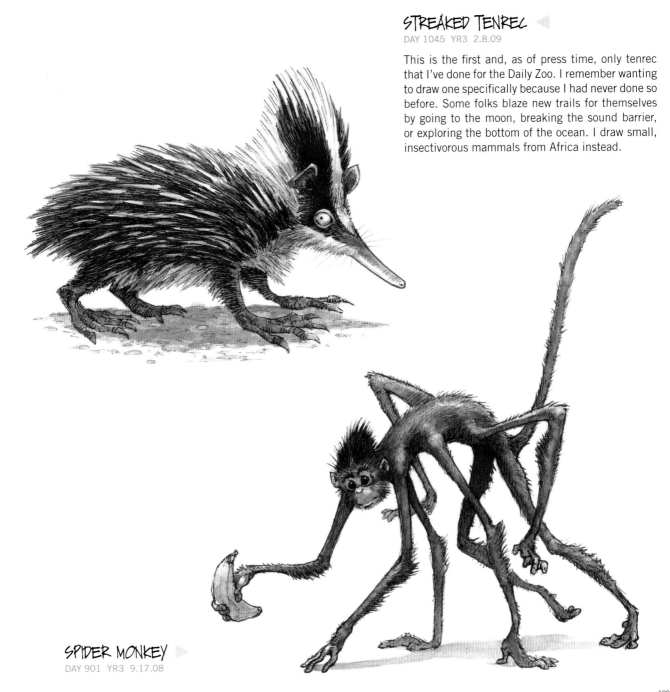

STREAKED TENREC

DAY 1045 YR3 2.8.09

This is the first and, as of press time, only tenrec that I've done for the Daily Zoo. I remember wanting to draw one specifically because I had never done so before. Some folks blaze new trails for themselves by going to the moon, breaking the sound barrier, or exploring the bottom of the ocean. I draw small, insectivorous mammals from Africa instead.

SPIDER MONKEY

DAY 901 YR3 9.17.08

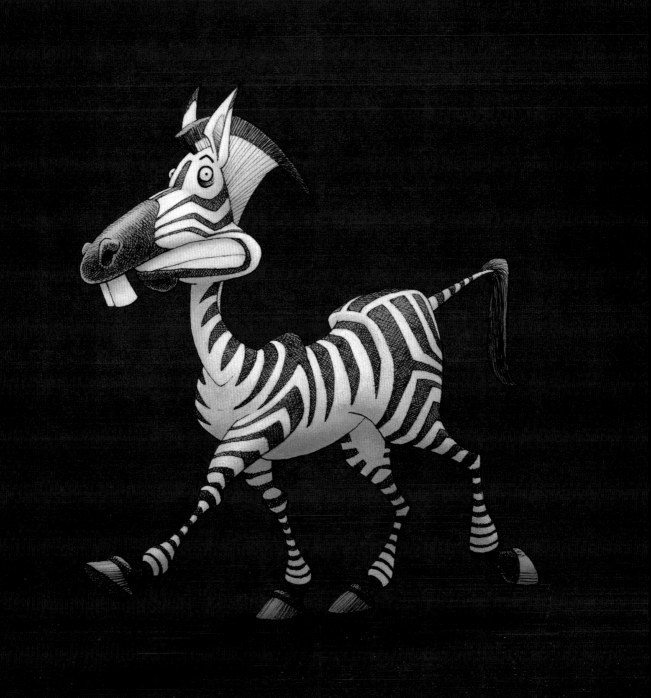

COCHIN CHICKEN ▶

DAY 908 YR3 9.24.08

This was drawn as a birthday request for my father-in-law, Dirk. He and his wife, Katy, had just received a pair of Bantam Cochins to add to their small flock at their Rhode Island home. These newcomers, Chelsea and Choo-Choo, joined four Rhode Island Reds (Charlotte, Christa, Chandra, and Chloe) as they took up residence in the coop called Clucksworth. And how do we lovingly refer to Katy when we go for a visit? Why, the Mother Clucker, of course.

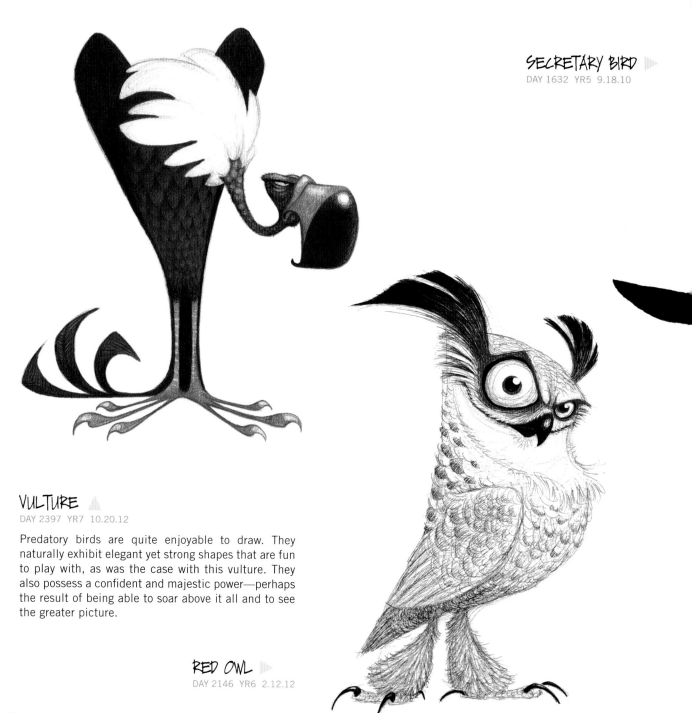

VULTURE 🔺

DAY 2397 YR7 10.20.12

Predatory birds are quite enjoyable to draw. They naturally exhibit elegant yet strong shapes that are fun to play with, as was the case with this vulture. They also possess a confident and majestic power—perhaps the result of being able to soar above it all and to see the greater picture.

RED OWL ▶

DAY 2146 YR6 2.12.12

GRIFFIN

DAY 784 YR3 5.23.08

Speaking of predatory birds, one ups the ante exponentially when throwing a bit of lion into the mix as with the griffin, a creature found in the mythologies of several ancient cultures. This is one birdie I wouldn't want to ask, "Does Polly want a cracker?"

GRIFFIN PICÁNTE

DAY 2171 YR6 3.8.12

Since the griffin is already a bit of a genetic mishmash, why not spice up the recipe with a dash of caracara? Caracaras are birds of prey, native to the Americas, with some species featuring an iconic black-feathered cap at the top of their heads.

BILLY GOAT ▶
DAY 2657 YR8 7.7.13

It's rewarding to periodically feel that the hard work is paying off and that my skills are gradually improving. With this goat, for example, I was pleasantly surprised with some of the shape- and proportion-related choices that I made, especially in the areas of his horns, eyes, and muzzle. This sketch, drawn in Year Eight, could probably not have been created in, say, Year Three. One of the benefits of practicing a skill every day is that it creates a forum to play, experiment, and push oneself into new territory.

FIVE TIMES THE FURY
DAY 823 YR3 7.1.08

Whatever you do, please, please, *please* try not to tick off the starfish.

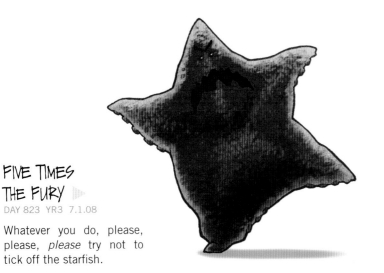

FURBITT
DAY 832 YR3 7.10.08

Though the exact details of the Furbitt's origin are a bit hazy, I do recall that I was having a phone conversation with Sloth, a friend from college. Mentioning that I had drawn a golfing frog the previous day led us to talking about a mutual friend—whom we sometimes affectionately refer to as the Hairy Norwegian—perhaps because he too is an avid golfer. Ultimately the conversation yielded the idea for one (very) hairy frog.

I was later surprised to discover that there is indeed a "hairy" frog, *Trichobatrachus robustus*, covered not in hair but rather fine threadlike skin extensions.

GIRAFFA ROBOTICA
DAY 838 YR3 7.16.08

I have long been a supporter of wildlife and environmental conservation efforts, dating back to elementary school in Minnesota when I wrote to my representatives in Congress about the importance of protecting the Endangered Species Act. You would think that by now we, as a species, would have learned how reliant we are upon the interconnected balance of Mother Nature. I hope that future generations will be able to experience such marvels as giraffes and elephants strolling across the African plains, not just robotic, man-made facsimiles. It would be the poorest of substitutes. (Full disclosure: I wasn't thinking of anything so profound when I was drawing this one. It was more like, "Cool! A robot giraffe!")

BOXY MOUSE
DAY 1871 YR6 5.15.11

MONGOOSE VS. COBRA ▼
DAY 839 YR3 7.17.08

I came across a photo of a banded mongoose while thumbing through an animal reference book. Its rounded, arched back and graphic pattern of stripes caught my eye, which conjured up the idea of a stylized, circular mongoose... which in turn led to a yin-yang theme, perhaps a natural choice given the legendary rivalry between mongoose and cobra.

CELEBES MACAQUE ▼
DAY 850 YR3 7.28.08

HANUMAN LANGUR ▲
DAY 855 YR3 8.2.08

Also known as grey langurs, these Asian monkeys get their Hanuman moniker from the Hindu monkey god of the same name and are thus widely considered sacred.

BALD EAGLE
DAY 735 YR3 4.4.08

GOTCHA!
DAY 2613 YR8 5.24.13

This was based on a photo of a giant otter that I had snapped the previous day at the L.A. Zoo. Because of their seemingly unlimited amount of playful energy, they are among my favorite animals to observe.

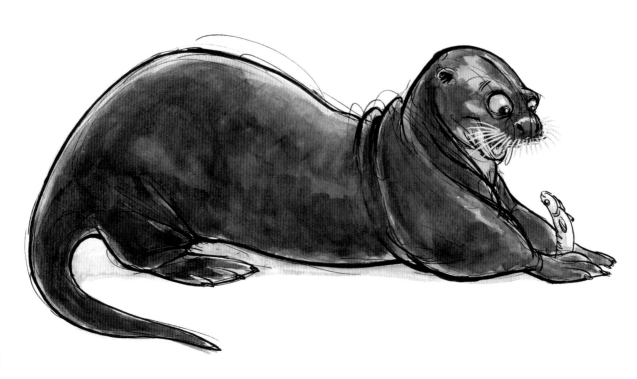

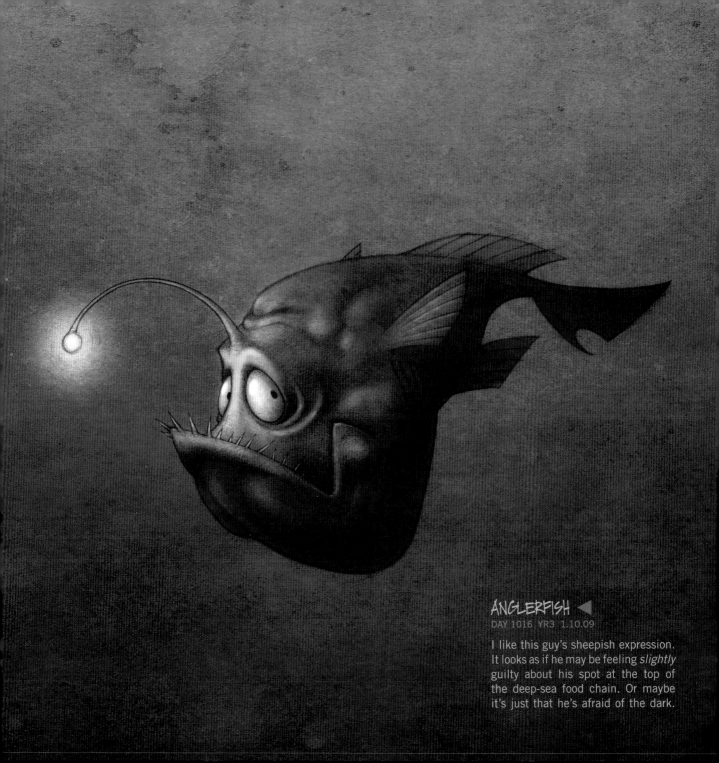

ANGLERFISH ◄
DAY 1016 YR3 1.10.09

I like this guy's sheepish expression.
It looks as if he may be feeling *slightly*
guilty about his spot at the top of
the deep-sea food chain. Or maybe
it's just that he's afraid of the dark.

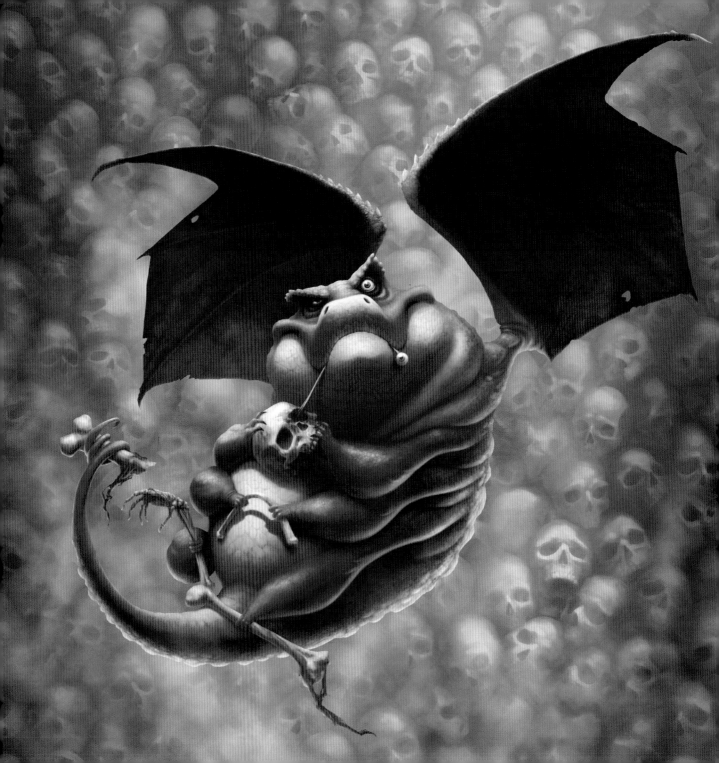

MUNCHASAURUS REX

DAY 1726 YR5 12.21.10

I was drawing Mr. Rex late one night while visiting my parents' home in Minnesota. On his way up to bed my dad looked over my shoulder and inquired about what I was drawing. "Some sort of six-limbed dragon eating an eyeball," I said.

His ever-so-casual reply was, "Ah…well, good night," as if it were the most normal thing in the world to be drawing! I feel very fortunate that both of my parents have always been extremely supportive and nonjudgmental of my creative endeavors. Not every artist is lucky enough to have that type of encouragement.

OPEN WIDE!

DAY 2449 YR7 12.11.12

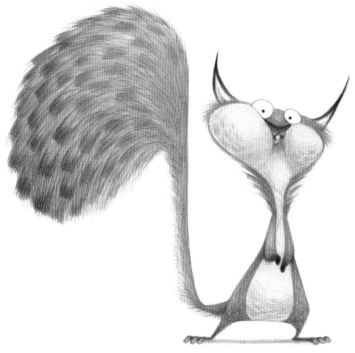

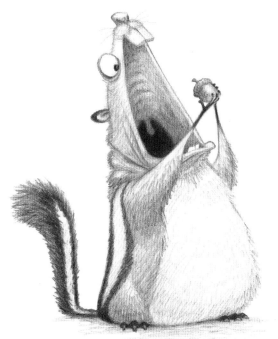

GRAY SQUIRREL

DAY 2665 YR8 7.15.13

I like to eat. So do a lot of the creatures and critters that I draw. I normally have a fairly healthy appetite, but that wasn't always the case. While I was undergoing treatment for leukemia, my appetite all but disappeared. Between the chemo- and radiation-induced mouth and throat sores, nausea, and a general feeling of malaise, it was all I could do to manage a few sips of a protein shake each day.

Once treatment had ended and my appetite began to return, I remember excitedly telling my oncologist that one of the nurses had recommended loading up on such things as hamburgers, steaks, and chocolate for the protein and calories. He quickly replied, "For a *WHILE!* Just a *LITTLE WHILE!*"

DAY 2223 YR7 4.29.12

I wondered if I could combine A through
Z—or at least A and Z—in one animal.

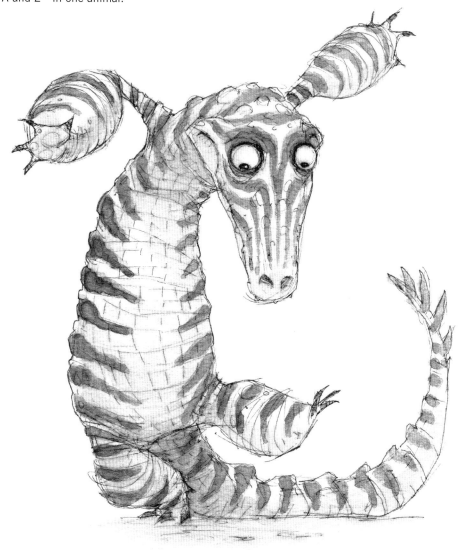

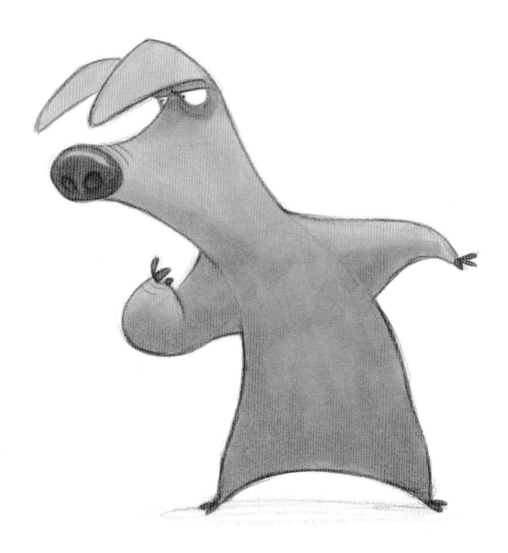
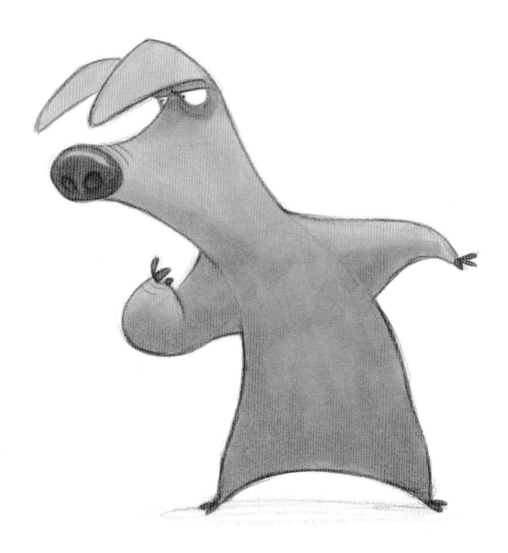

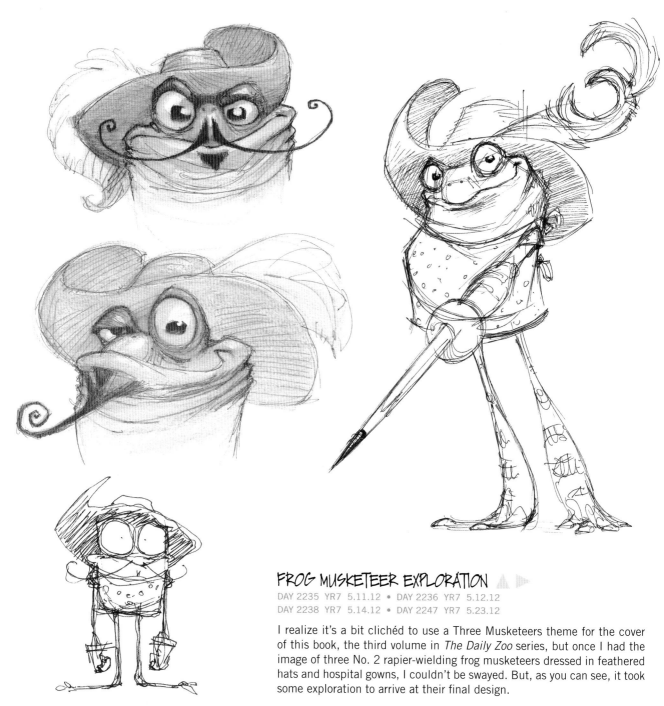

FROG MUSKETEER EXPLORATION

DAY 2235 YR7 5.11.12 • DAY 2236 YR7 5.12.12
DAY 2238 YR7 5.14.12 • DAY 2247 YR7 5.23.12

I realize it's a bit clichéd to use a Three Musketeers theme for the cover of this book, the third volume in *The Daily Zoo* series, but once I had the image of three No. 2 rapier-wielding frog musketeers dressed in feathered hats and hospital gowns, I couldn't be swayed. But, as you can see, it took some exploration to arrive at their final design.

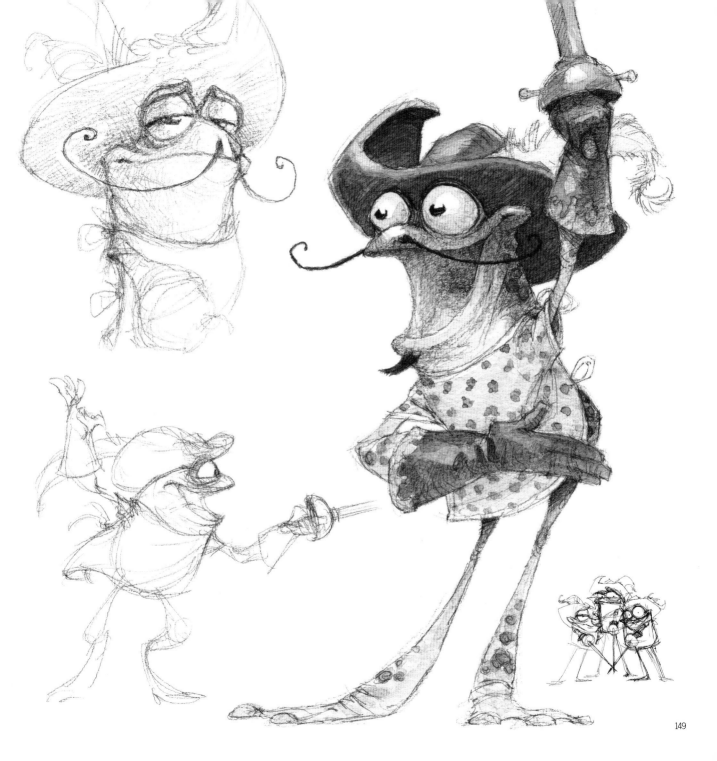

TASMANIAN DEVIL

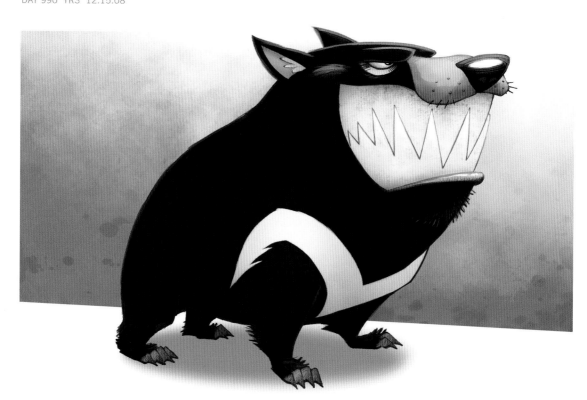

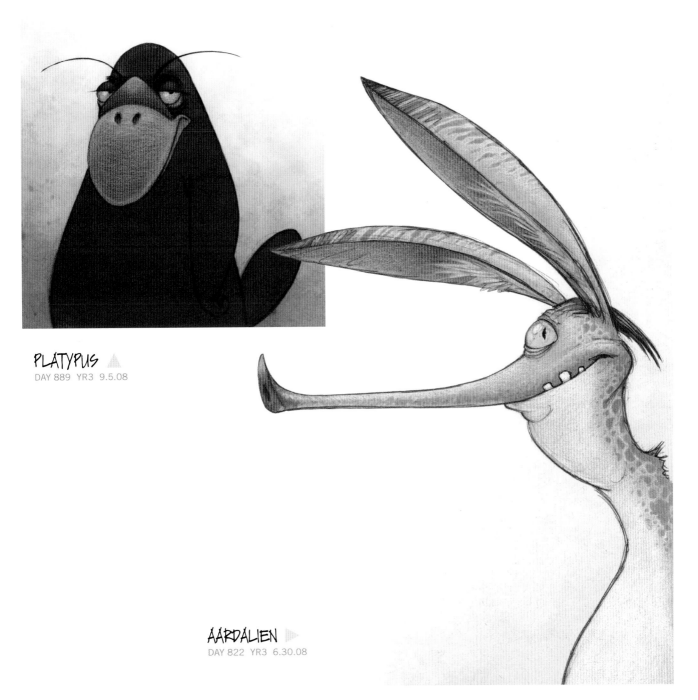

PLATYPUS
DAY 889 YR3 9.5.08

AARDALIEN
DAY 822 YR3 6.30.08

THE SNOUTS ▶▶

Snouts are gentle creatures native to the planet Frangoon. Based on their appearance, it may come as no surprise that they experience the world around them primarily through their olfactory senses, even communicating through an elaborate "language" of scent markings and complex pheromones.

With the emphasis that Snout culture puts on scents, the more layered and varied an individual's unique "odorous aura" is, the wiser that individual is believed to be. With stink comes respect. Individuals who buck these long-established cultural norms by bathing regularly are promptly ostracized by the rest of society.

HIGH HOG ▶
DAY 2396 YR7 10.19.12

Sometimes you just gotta go for it!

Even space monsters get spooked from time to time.

FRIDAY MORNING...CORNER
OF WALNUT & 5TH...9:52 A.M.
DAY 2725 YR8 9.13.13

This was drawn on a Friday the 13th so
I veered toward the theme of bad luck.
Normally rabbit's feet are associated with
bringing good luck, but I'm not so sure
that will be the case here. For whom will
this chance encounter be unlucky? The
rabbit? The man? Both? Neither?

ARE YOU DANCING TODAY? ▶

While not officially one of the daily sketches from the Daily Zoo, this polychromatic hippo was done for the *MY Daily Zoo* drawing activity book that was published a few years ago.

I actually have him hanging on the door to my studio, and it's a subtle reminder for when life gets overly busy and stressful. *Am I dancing today?*

Amidst the avalanche of emails, texts, and bills... the calendar laden with meetings, deadlines, and other responsibilities...the cacophony of traffic jams, parking tickets, and a constant stream of distressing events on the nightly news, it can be a continuous challenge to remember what is truly important in life. What *matters*. What brings *joy*. What brings music to the *soul*. While each person's list will vary, if you start off with family, friends, health, meaningful work, and fulfilling, creative play, you're in pretty good shape.

So with that, *The Daily Zoo, Vol. 3* comes to a close. I hope that you will continue to find ways—even small ways—to bring your passions into your daily life.

Until we meet again, *dance on!*

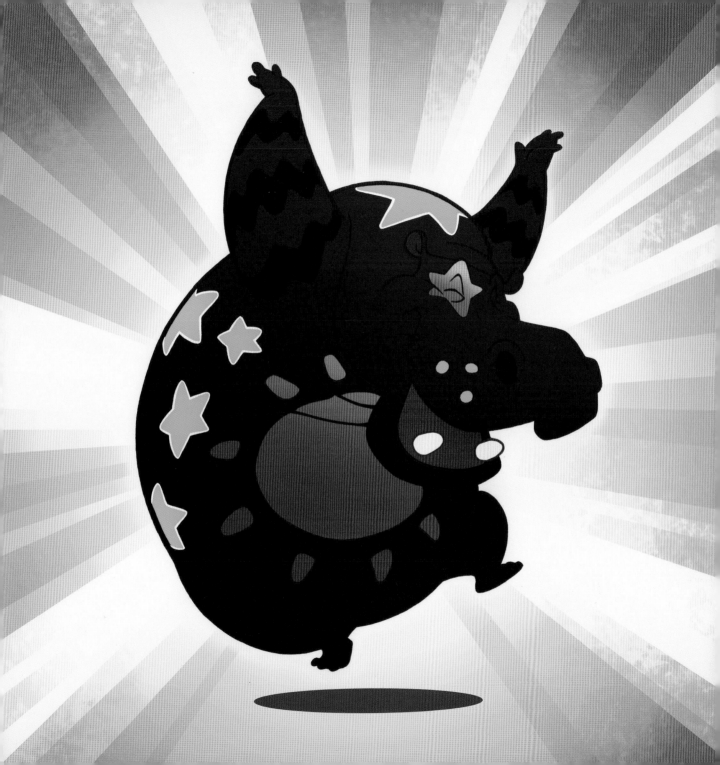

is your collection complete?

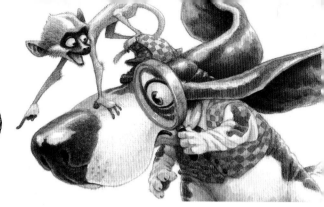